IMAGES
of America

OLYMPIC
HOT SPRINGS

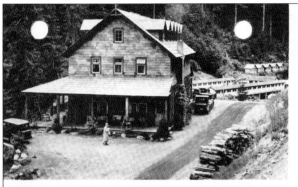

Olympic Hot Springs Lodge As You Drive In

LODGE RATES

Single$4.50 per day $28.00 per week
Double 8.50 per day 52.00 per week
Special Rates for Children Meals and Bathing Included

CABIN RATES
FURNISHED
(Includes Bedding, Dishes, Cooking Utensils and Silverware)

Per Cabin

1 Double Bed, per day................................$ 2.00
 per week .. 12.00
1 Double Bed, with lavatory and
 running water, per day.....................$ 2.50 3.00
 per week .. 14.00 16.00
1 Double and 1 Single, per day................ 2.50
 per week .. 14.00
2 Doubles, per day................................ 3.00
 per week .. 16.00
2 Double Beds with lavatory and
 running water, per day.................... 3.50 4.00
 per week .. 18.00 20.00
No Table Linen Furnished

At the camp store all groceries may be procured at pre-vailing market prices. Fresh milk, meat and vegetables are received daily. Stock is kept complete for those who cook their own meals and want them good.

SWIMMING AND BATH PRIVILEGES

Adults ..$3.00 per week each
Children under 12................................. 1.50 per week each

For reservations or additional information
write, wire or phone—

OLYMPIC HOT SPRINGS

HARRY S. SCHOEFFEL, Manager
Port Angeles, Wash.

HOW TO GET THERE—

There are many choices of routes—by water and by car. You can take ferries from Seattle direct to Port Angeles . . . or to Bremerton and again from Seabeck to Brinnon . . . or from Mukilteo or Edmonds to Whidby Island and again to Port Ludlow or Port Townsend.

Driving, you can take Highway 101 through Olympia and skirting Hood Canal or through Grays Harbor and around the ocean route.

Highway 99 from Portland takes you through Seattle and, for a longer but beautiful trip through the San Juan Islands, you can go on to Bellingham and ferry to Victoria, B. C., and again to Port Angeles.

A motor bus leaves Seattle every morning taking you right to Port Angeles. Our car leaves Port Angeles during July and August daily at 1:30 from motor bus depot, or Lee Hotel. Other months on call. Round trip $2.00.

During the 1930s, this brochure was used to advertise the Olympic Hot Springs resort. It included a map of the Olympic Peninsula to show travelers how to get there and a list of rates and amenities. (Courtesy of Clallam County Historical Society.)

ON THE COVER: This postcard photograph, taken by an employee of the Clive Fehly Studio in Port Angeles, was sold at the Olympic Hot Springs resort during the 1930s. Fehly was on the Harry Schoeffel payroll as a steady postcard producer for years, as was J. Boyd Ellis. These photographers sold their work to many resort owners on the Olympic Peninsula. (Courtesy of the Schoeffel family collection.)

IMAGES
of America

OLYMPIC
HOT SPRINGS

Teresa Schoeffel-Lingvall

ARCADIA
PUBLISHING

Published by Arcadia Publishing
Charleston, South Carolina

Printed in the United States of America

Library of Congress Control Number: 2013930758

For all general information, please contact Arcadia Publishing:
Telephone 843-853-2070
Fax 843-853-0044
E-mail sales@arcadiapublishing.com
For customer service and orders:
Toll-Free 1-888-313-2665

Visit us on the Internet at www.arcadiapublishing.com

To my family, the Everett, Schoeffel, Oxenford, Hinnebusch, Lippert and Sailer clans, for their remarkable strength and devotion to the success of Olympic Hot Springs. We salute you, O Pioneers!

CONTENTS

ACKNOWLEDGMENTS

The Schoeffel and Everett family left behind many photographs and documents regarding the life of the Olympic Hot Springs resort. They were scattered in various places about the old farmhouse in Port Angeles, Washington. The main treasure trove was found in the attic after great-uncle Carl Everett passed away in 1991. I want to thank my sister, Allure Johnson, who assisted me with organizing boxes of unidentified photographs and various memorabilia. We would spread the items on her living room floor, sometimes examining them into the early hours of the morning, reveling in our family's history. We spent hours sorting the photographs. Without dates or descriptions, it was quite a journey to identify them. The fascination of the old family photographs and memorabilia, and the confusion as to why our family lost the resort to Olympic National Park, all climbed into my heart, and I knew that someday I would present the legacy of my grandparents and great-grandparents and their diligent work in operating the resort.

When I decided I was going to create an exhibit to tell the story of Olympic Hot Springs, I contacted the Clallam County Historical Society, and I want to thank Kathy Monds, who prompted me to pursue a project for the county museum. After all the research, scanning, cutting, pasting, typing, and printing, along with having photographs all over my living room floor, the Olympic Hot Springs exhibit opened in the Museum at the Carnegie in 2012. I want to thank historian and author Alice Alexander, who attended the exhibit opening and said to me, "Now you need to do a book."

I thank my parents, my family, friends, Port Angeles Library, Gay Hunter from Olympic National Park, Doug, John, and my children, Jeremy and Stephanie, for all their support. I also wish to thank my editor, Alyssa Jones. With great honor to my ancestors, I present their history in this book.

Unless otherwise noted, all photographs in this book are from the Schoeffel family collection. Throughout the 59 years the resort was in operation, many photographs were taken by various photographers. The proprietors of Olympic Hot Springs purchased these photographs throughout the years and made them into postcards without retaining original information. I apologize that I was not able to credit all the unknown photographers in this acknowledgment, but I want to thank them for their work.

INTRODUCTION

The S'Klallam tribe knew of Boulder Hot Springs. A S'Klallam medicine man named Boston Charlie was said to have dwelled there, and he showed the springs to Billy Everett when Everett was a young boy. According to Port Angeles history, the first white man to find the springs was Andrew Jacobsen in 1892. He promptly left the steaming hillside that bubbled with mineral water, assuming that it was volcanic and about to explode.

Jacobsen was not successful in establishing any claim to the springs. In 1907, the hunting party of Billy Everett, Thomas "Slim" Farrell, and Charlie Anderson came across them, made a tub from a hewed-out log, flumed in some hot mineral water, and after soaking in the soothing water, established a retreat 12 miles into the Elwha Valley at Boulder Creek Canyon.

Everett and his crew named their discovery Olympic Hot Springs, thus beginning a destination resort that would draw thousands of visitors during its 59 years in business. The springs were set in a fairly inaccessible area 21 miles from Port Angeles at 2,100 feet in elevation. It was accessed by following the Elwha River and meeting a tributary called Boulder Creek. The 21 springs varied in temperature from lukewarm to 138 degrees Fahrenheit.

One of the three founders, "Slim" Farrell, filed a mineral claim to establish rights to the springs and posted a location notice required by law. Charlie Anderson withdrew from the enterprise, and Farrell later sold his claim to Billy Everett, who went on to develop the resort. From 1907 to 1908, a trail was blazed to the springs, and a modest cabin was built. A pool was dug out by Everett, his wife, Margaret, and those who wanted to invest in the project.

Bridges were built over the Elwha River in the early 1900s, and much of the trail to the springs was maintained by the Everett family, homesteaders, and pack train crews. Maggie Everett, her sister Anna Oxenford and Anna's husband, Karl, along with the Sailer and Hinnebusch families, all became involved with the early construction of the enterprise. Later, George Lippert, a cousin, became a partner with Everett. Karl Schoeffel, Maggie's brother, moved from Evans City, Pennsylvania, to join the partnership, named "Everett, Lippert and Schoeffel, The Olympic Hot Springs Company."

It was a family venture from beginning to end. In 1908, word spread throughout the Port Angeles area, and folks began hiking the Elwha Trail 12 miles from the road that is now Highway 101.

Many came on horseback, and the popularity of the springs grew. People came for healing and recreation, and some visitors camped out for weeks. This prompted the Olympic Hot Springs partners to build tent frames and rent them out.

A lodge and quarters were built with lumber acquired from logging the site. The hot mineral water pool was dug with hand shovels, and tubs were made out of logs. In 1910, a good-sized pool was dug out from a mining site with logs cut, planed, and placed tightly together to hold the mineral water. It was the first pool of its type in Clallam County.

From 1908 to 1913, Dewey Sisson ran a pack train up the trail to the springs from his establishment, the Mountain Inn, near where the entrance is now to Olympic National Park. Sisson charged the

hot springs patrons 3¢ a pound to bring supplies up the trail. He also brought up the sawmill in 1910, which promoted a surge in construction at the site. At 3¢ a pound, he made pretty good fare.

There was a falling out between Sisson and the Olympic Hot Springs Company in 1912, and Bert Herrick, who operated a store and lodging across the Elwha River, replaced Sisson. Herrick charged only 2¢ a pound for freight. Herrick's pack train left for the hot springs twice a week with a fare of $2. He operated the pack train for 10 years.

In 1909, a dam and a waterwheel were built by Walter Goodwin on Boulder Creek, supplying power to the sawmill and later producing electricity for the resort. In 1914, the proprietors of the Olympic Hot Springs Company, Everett, Lippert, and Schoeffel, drafted proposals to the US Forest Service for a lease of 12.5 acres, asking to make continual improvements and expansions to their growing community.

With the sawmill and waterwheel in operation, a lodge was built in 1917. With it came a second wooden pool, 75 feet long and 25 feet wide, and many more tent cabins. Boardwalks were installed to cover the muddy ground. A tall bridge 175 feet above Boulder Creek was built by Everett and Ben Owens. In 1919, cabins were built to replace tent frames, and prospects were looking good. Then, a fire occurred at the first lodge. A new location was cleared on the opposite side of Boulder Creek, and building plans for the new lodge began in 1920. The construction took six years due to a heavy snowfall in 1923, which caused the roof and framework to collapse under the weight. Snow would damage many surrounding buildings in this way throughout the years, and the road to the springs would wash out during heavy winters.

The hotel was completed in 1926, boasting 10 sleeping rooms, a dining room, a handsome lobby adorned with Navajo rugs, and a rock fireplace with elk horns mounted above the mantle. The walls were adorned with hunting trophies of Billy Everett, including a few of his cougar pelts.

Maggie Everett, along with her mother and sisters, would take excursions to bring in wildflowers for the dining tables and wild mushrooms for the stew pot. Billy Everett and his nephews would bring in game and fish for the kitchen. There was a large patch of watercress that grew along a stream by Boulder Creek, and the plant was incorporated into salads. Additional supplies and guests would arrive on pack trains and on foot, including Maggie Everett's mother, Elizabeth Schoeffel, who, in her mid-70s, made the 12-mile hike.

With the Roaring Twenties came new inventions, and the automobile made travel more accessible. The Everetts anticipated a road to be completed to cater to more guests.

Electricity became available in 1914, when the Lake Aldwell Dam was completed on the Elwha River. However, Olympic Hot Springs generated its own supply by way of a waterwheel built by Ben Owens. The waterwheel spun and controlled the speed of saw blades cutting lumber inside the mill, and the resort's expansion bloomed.

The Elwha River Valley was spotted with various outposts, lodges, homesteads, and farms during the 1890s. However, in the early 1950s, much of the land was annexed into Olympic National Park, forcing residents to relocate.

In 1920, Harry Schoeffel began to live and work at the resort. Schoeffel, the nephew of owners Maggie Everett and Karl Schoeffel, married Everett's daughter, Jean, in 1921. The following year, he bought out his uncle Karl and joined in the partnership. George Lippert sold his share when he joined the service during World War I. Harry and Jean Schoeffel eventually took over management of the enterprise from her parents in 1924 and continued to run the resort for 43 years.

Two fires ravaged two of the three lodges. One of the blazes took down the "jewel of the fleet" in 1940, which had taken many years to build. The hotel was visited by many notable individuals from 1926 to 1940. Zane Grey, the Western novelist, stayed for a week. Singers Jeanette McDonald and Nelson Eddy stayed in 1936. In 1930, Prince Olav and Princess Martha of Norway were guests during a US tour sponsored by President Roosevelt. There is also mention of the Von Trapp family, about whom the movie *The Sound of Music* was written, speaking in their German tongue at the resort. Unfortunately, the old guest registers have yet to be recovered.

From 1924 through the early 1930s, the road leading to Olympic Hot Springs was under construction, with the collaboration of the US Forest Service and the Clallam County road-

building crew. During this time, before completion of the road, Harry Schoeffel leased the Altaire Campground along the Elwha River, making two trips a day with his own pack train of horses up the winding trail to the resort.

With the road finished in 1937, business was booming, giving way to construction of a cement swimming pool at a cost of $30,000. The pool was later dedicated by Olympic gold medalist Helene Madison and her coach, the renowned Ray Daughters of Seattle's Washington Athletic Club. Daughters coached many swimmers to gold medals. The crowd that came to watch Madison break yet another world record in the pool cheered wildly, swarming the grounds of the resort.

In 1932, more guest rooms were added to the lodge, bringing the total to 20. Mud baths and private tub rooms were also made available. Connecting the second lodge with the cabins and pools across Boulder Creek Canyon were two bridges, one at the north end of the complex for people and horses and a later one at the south end to provide a route for automobiles.

The hosts of the resort offered meals, cabins, rooms for rent, guided hiking and fishing, daily mail service, telephone service, and taxi service 21 miles from Port Angeles. With the two pools for swimming and a lobby store with provisions for the guests, folks would stay for weeks. The cabins were covered with knotty pine paneling inside, and all contained wood cook stoves, providing steady employment for woodcutters. Lodge rates were $4.50 per day during the late 1930s, and cabins were $2 a day. In the late 1930s, a campground was created above the resort on the west side of Boulder Creek. The lodge and resort boasted over 800 electric lights throughout. The fire that burned the hotel on the fateful night of January 27, 1940, left nothing behind but the main chimney. The rest of the resort was not affected, for it rested across the canyon on the eastern side of Boulder Creek.

Jean and Harry Schoeffel were in Pittsburgh, celebrating their parent's 50th wedding anniversary, at the time of the fire. The tragic story hit the front page of the *Port Angeles Newspaper*. Damages to the lodge were estimated to be around $19,000. Luckily, the lodge was insured, and the determined owners proceeded to build a third lodge across Boulder Creek by adding a second story to the existing bathhouse overlooking the pools.

In 1941, a "music box" was purchased for the new lodge at a cost of $226, accompanying guests as they danced in the lobby and swam in the pools. A local man told of how his parents would stay at the resort in the 1940s and hold Chautauqua sessions. Guests would entertain each other with the talents they brought with them. But, along with the fun, there was much frustration for the owners, as the snows of winter caused roofs to cave in and washouts on the road.

Seasonal staff resided in quarters below the guest dressing rooms, and the lodge provided quarters for the owners and family. Teenage employees required special work permits to stay for the summer. The Schoeffels' grandchildren also stayed during the summers, providing a challenge for the owners to keep track of their whereabouts after hours. There were many trips "to town" for supplies, with Bob Schoeffel, the owner's son, boasting of the record for speed down the winding road to Port Angeles. Many merchants in Port Angeles did business with Schoeffel, who always wore his fedora and had his cigar clamped between his teeth. Jean Schoeffel operated the dining room and cooked many of the meals for guests and the staff. She exalted in her pies, made with berries picked on the hillside of the springs.

The employee roster included lifeguards, woodcutters, desk clerks, waitresses, cooks, laundry help, and cabin maids. The "fix-it" guys included family members and friends. Johnny Baker, manager of nearby Glines Canyon Dam, was an electrician and friend of the Schoeffels and could often be seen at Olympic Hot Springs, troubleshooting various electrical problems.

By the 1950s, Olympic National Park began to enforce requirements and demands on the Schoeffels' operations at the resort, including many lease agreements and higher lease payments. The National Park Service incited resentment from the resort owners, especially in 1955, when the Schoeffels were told they could not use the hot mineral water because it contained bacteria. This resulted in the reduction of half of their business for a year, as the resort's main attraction was unavailable. For the 30 years prior to the involvement of the National Park Service, there were no reports of bacterial infection from patrons using the mineral water.

The 1950s brought more travelers to the resort, including nature photographer Herb Crisler, who had come to shoot film for Walt Disney. He befriended Billy Everett, and the two hiked up into the Olympics well into Billy's 70s. In 1952, a boy drowned in the pool; following a settlement, a lifeguard was always present poolside.

During the late 1950s, automobiles became more luxurious, while the resort started becoming antiquated. Many visitors still enjoyed the rustic charm, but more modern retreats were preferred. Even with the Wurlitzer jukebox ringing out the latest tunes of 1959 to swimmers, the resort began to decline.

As the Schoeffels reached retirement, the National Park Service did not reissue a lease to operate the resort beyond 1966. The fate of the resort was in the hands of the federal government and at the mercy of the winter snow. The battle between the owners and the government continued for six years. In 1972, the National Park Service restored the land to its "natural state," demolishing all standing structures.

In the wake of this loss and sad demise, I bring this collection of photographs from the Schoeffel family and from other collections to replace the illusion of "never was" with the reality of "always will be." With pride, this book is in memory of the beloved pioneers who never gave up and those who came when life was lived at a resort called Olympic Hot Springs.

One

THE "MOWICH MAN"
BILLY EVERETT

Billy Everett was a man with sheer determination and remarkable stamina. Being half S'Klallam native via his mother, who died when he was young, Everett went on to achieve notoriety for many accomplishments. Raised by the S'Klallam family of Boston Charlie, a noted medicine man, Everett was introduced to much of the Olympic Mountain wilderness. He was an excellent marksman with a gun, and his ability to move through the brush left many who traveled behind him catching their breath. He was stealthy and knowledgeable of his whereabouts in the forest, and his quick wit matched his cunning ability.

Billy was born William Everett on February 28, 1868, to John Everett and Mary Pysht near Joyce, Washington. Losing his natural parents, he grew to hunt and sustain himself through the teachings of his tribe and Boston Charlie, who is said to have lived to be 100 years old.

Everett grew up along the Elwha River, learning woodworking and hunting skills. He went on in 1893 to marry Margaret Schoeffel, who had come from Germany as a young girl. They had three children, one of whom drowned in Cat Creek near the Elwha basin. Everett started the Olympic Hot Springs resort in 1907. When he was not running the resort or working on his ranch, he was roaming the wilderness for game. With a record of 99 cougars to his name, he went on to become a legend during his pioneering life of 82 years on the Olympic Peninsula.

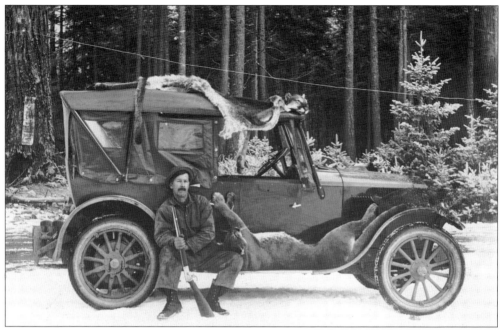

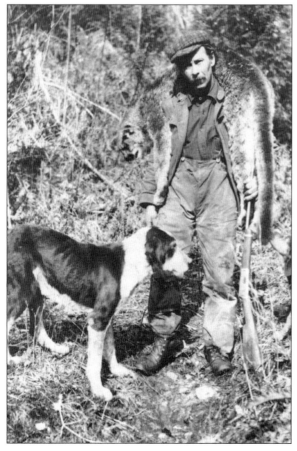

Billy Everett poses in 1915 with the family Ford. This photograph, taken by Burt Herrick after a two-day hunt in the Upper Elwha Valley, is a favorite of history buffs. An electrical line is nailed to the tree behind the car.

Everett shot 99 cougars in his life and was well known throughout the Port Angeles area as "Mowich Man" ("deer hunter" in the Chinook language). This photograph was taken in 1918 by Grant Humes, who lived in the Upper Elwha Valley.

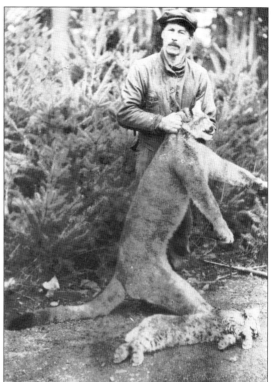

Billy Everett, who hunted until he was 78 years old, accumulated 99 cougars to his name. He poses at right for Grant Humes, who was also a pioneer in the Upper Elwha area. Humes was host to the Seattle Press Expedition in 1889, commissioned by Washington State's first governor, Elisha Ferry, to survey and name geographic landmarks in the Olympic Mountains. Everett was also a well-known elk hunter.

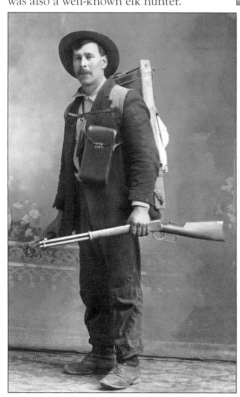

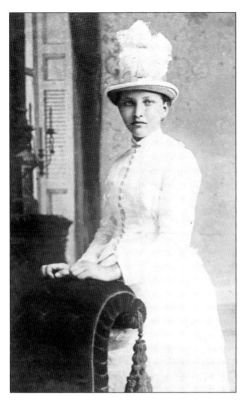

A 13-year-old Maggie Schoeffel poses for a photograph taken in a San Francisco studio in 1891. She arrived in America from Germany when she was 10 years old, and she and her mother, Elizabeth Schoeffel, came to the Port Angeles area and resided in Upper Eden Valley near the Everett farm, where her future husband lived. Maggie was the youngest of her eight brothers and sisters. Her four sisters came out to live in the West, and her four brothers stayed in the Pittsburgh, Pennsylvania, area, with the exception of her brother Karl, who became a partner in Olympic Hot Springs in 1909.

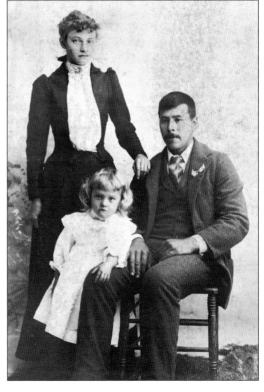

Billy Everett married Margaret Schoeffel in 1893. She was 15, and he was 10 years her senior. They settled on the Everett homestead, located at Freshwater Bay in Port Angeles. The couple had three children, two boys and a girl. Jeanette, their firstborn child, is seen here in a family portrait taken in 1897.

John Everett (right), Billy's father, came to Washington from Canada in 1862. Originally from the Midwest, John Everett joined forces with John Sutherland and found work mining gold. They met again at the Hudson Bay trading post in Victoria, British Columbia, and made their way across the Straits of Juan de Fuca in canoes, landing west of Port Angeles. John met Mary Pysht, a native S'Klallam woman, and settled in the Freshwater Bay area to the west of Port Angeles. Everett and Sutherland went on to have two large lakes on the Olympic Peninsula named after them. Lakes Sutherland and Everett (later named Lake Crescent) are large pristine lakes in Olympic National Park.

Margaret "Maggie" Everett (right) poses here with her mother, Elizabeth, who bore 9 children. In 1888, Elizabeth Schoeffel brought the last two of her children to America from Germany following her husband's death. Maggie, 10, was the youngest to make the trip. Elizabeth, who lived to be 98 years old, made the 12-mile trek up the Elwha Trail to Olympic Hot Springs at age 75.

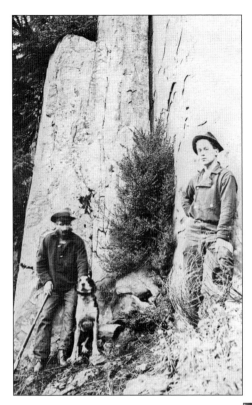

Shown here are hunting partners of Billy Everett, Thomas "Slim" Farrell (left, with Babe the hunting hound) and Charlie Anderson. The two men joined with Everett to start Olympic Hot Springs in 1907.

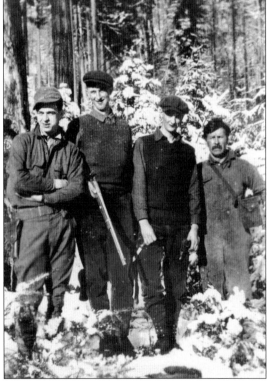

This hard bunch of men, with two who were owners and operators of the Olympic Hot Springs resort, went on many work and hunting expeditions together. Shown here are, from left to right, Harry Schoeffel (owner), his cousins George and John Schoeffel, and Billy Everett (owner).

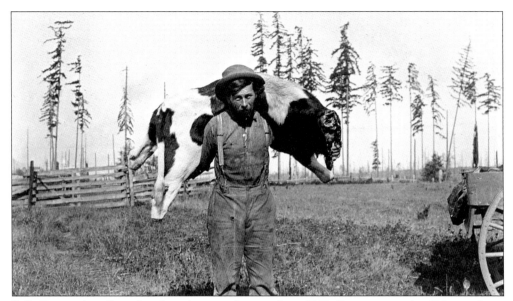

Billy Everett handles a butchered cow at his ranch in 1910. Everett owned a 100-acre farm, which he operated with the help of his son, Carl. While his parents were away at Olympic Hot Springs, Carl would manage the ranch with his cousins. The ranch became Carl's after his father passed away.

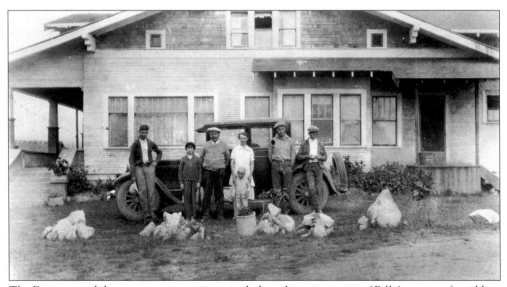

The Everett ranch house saw many visitors, including those inquiring of Billy's services for ridding their farms of cougars. Billy, his wife, Maggie, and their two sons, Carl and Fred, raised beef, produce, hay, eggs, and pigs. Shown in this 1931 photograph are, from left to right, Carl Sailer, Barney Hinnebusch, Joe Sailer Sr., Maggie Everett with her grandson Bobby Schoeffel in front of her, Carl Everett, and Joe Sailer Jr.

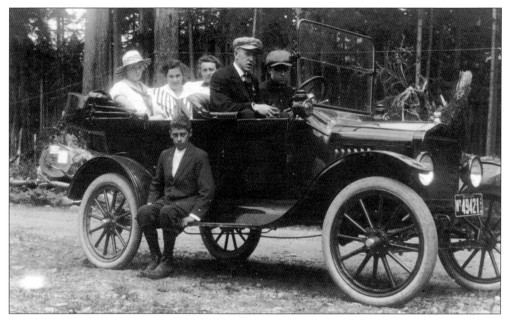

Carl Everett is behind the wheel of the family car in this 1912 photograph. From left to right in the backseat are his cousin Lucy Blater; his sister, Jeanette; and his mother, Maggie Everett. His uncle Joe Sailer is the front-seat passenger, and his younger brother Fred Everett sits on the running board.

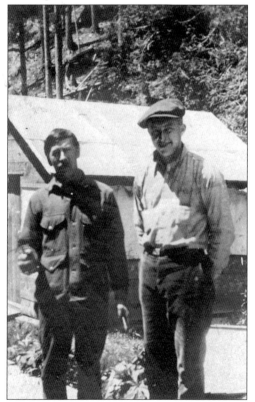

Billy Everett (left) is seen here at Olympic Hot Springs with Joe Sailer, his brother-in-law. This is one of the few photographs of Billy standing for a photograph at the resort. He was always busy about the place. Sailer was a regular patron and partial investor for the Everetts in 1917.

Thomas "Slim" Farrell rests against stacks of shingles that he and Billy Everett split with a froe for the new lodge under construction in 1922. On this day, Farrell and Everett went out for a hunt, and Farrell is photographed with the hunting dogs and the pelts from their endeavors.

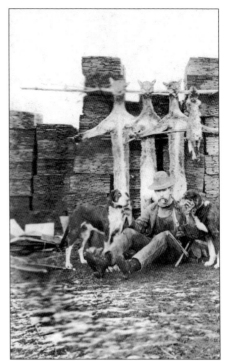

Billy and Maggie Everett celebrate 50 years together with a party at Olympic Hot Springs. The years were filled with farming, raising children, building a resort together, and the many days and nights Maggie spent waiting for Billy to come home from cougar hunts.

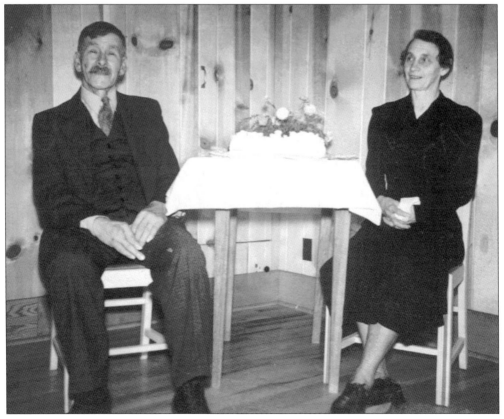

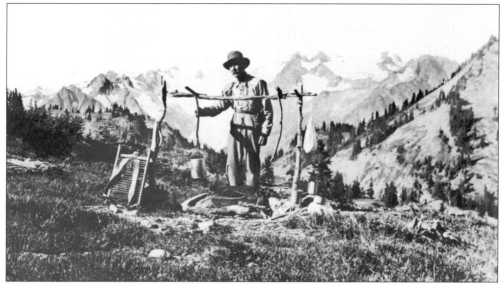

Everett, well into his 70s, takes a trip into the Olympic Mountains in 1945. He is standing at a fire spit with the beautiful mountain peaks in the background.

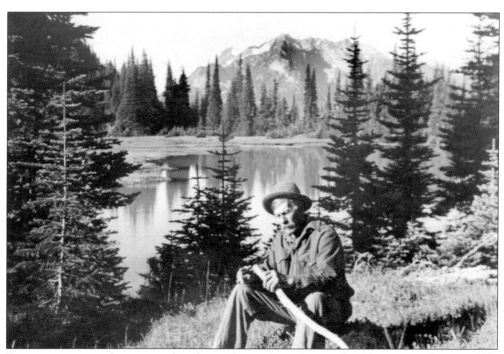

Everett was a marvel to many when he made another trip into the Olympics at the age of 78. It is said that he climbed along Wild Cat Ridge, a rock cleaved half a mile long between Cat Mountain and Mount Carrie, then along the crest of the Bailey Range at timberline, and finally dropped into the alluring charm of Cream Lake. The lake is one of his claims to fame, having found it as a young boy. Here, Everett carves on a stick to make a skewer for the campfire in 1946 with Cream Lake in the background.

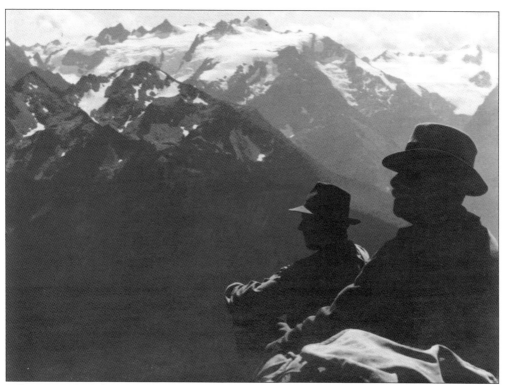

Billy Everett (right) and Herb Crisler, a Disney photographer and fellow mountaineer, take time to admire the view of the Olympic Mountain Range. The two spent many years in the wilderness with cameras and rifles.

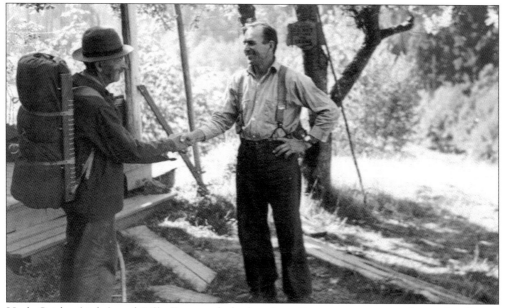

Herb Crisler (right) and Billy Everett shake hands as Everett prepares to depart for Cream Lake. Everett, now in his later years, was accompanied by an unknown photographer for this trip in 1946.

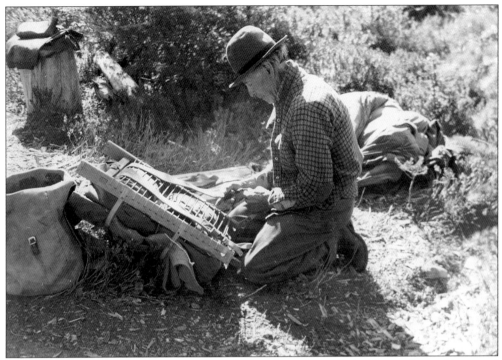

Everett prepares his pack before carrying on further through the Bailey Range during his annual trip in the Olympic Mountains in 1946. (Courtesy of Olympic National Park Archives.)

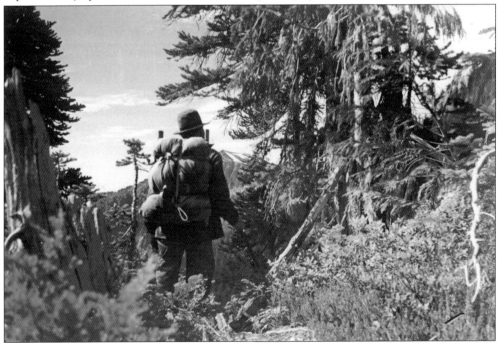

The back of Billy "Mowich Man" Everett faces the camera as he presses on through the Bailey Range toward his destination. He was still "quite keen with his sight in his late years," reports Jack Henson, who wrote about Everett in many news articles for the Port Angeles newspaper.

Here is Babe, the faithful hunting hound who gained fame during his 12 years of leading and protecting Billy Everett in many hunts for cougar, wolf, cat, and bear. Babe, praised by many as extraordinary, had an uncanny sense of where the cougars were likely to go. He was known to stay with a treed cat for hours until the hunters arrived. After wolf hunts, Babe would be the only dog to come back alive. Once, having gotten his foot caught in a trap, he returned dragging the chain. Babe brought down at least 100 animals. When he passed on, a lengthy article about him appeared in the local newspaper.

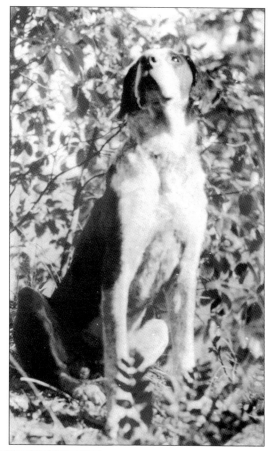

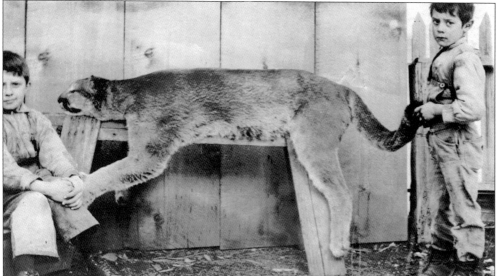

Carl (right) and Fred Everett pose with one of their father's trophies. Billy Everett not only had 99 cougars to his name, but he was also noted for over 100 elks, bears, and deer. Fred Everett drowned in Cat Creek at the age of 16. (Courtesy of the Kellogg Collection.)

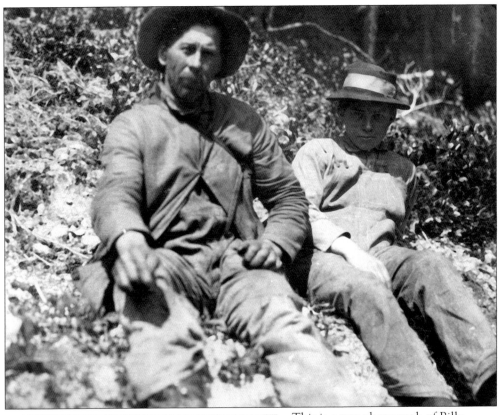

This is a rare photograph of Billy Everett with his young son Carl. Billy was often away, tilling the fields on the farm, working at Olympic Hot Springs, or hunting. This photograph was taken around 1910. (Courtesy of the Charlie Jones/Hinnebusch family collection.)

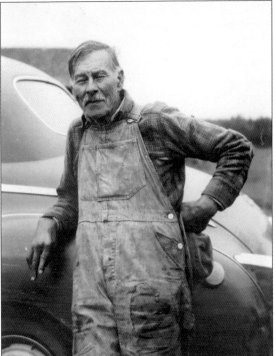

Billy Everett is seen here as he approaches 80 years of age. He lost part of his hand in an accident yet continued to hunt and work at his ranch after retiring from the Olympic Hot Springs resort. In October 1950, he was gathering apples in a tree at his ranch when he fell and injured his head. He died a day later at the age of 82.

Two

THE EARLY YEARS OF OLYMPIC HOT SPRINGS

In 1907, the Seattle Mountaineers came up the Elwha Valley with renowned photographer Asahel Curtis. Grant Humes, an early pioneer on the Upper Elwha River and friend of Billy Everett, served as their guide into the Olympics.

With long and arduous days of clearing and slashing a trail along the Elwha River in 1907 and 1908, the Everett, Farrell, and Anderson team managed to make way for guests. The humble beginnings of the single cabin and earthen pool caused word to spread, and soon, people found their way to the resort. People would camp and stay for weeks, according to Jean Schoeffel, the last owner of the resort.

Later in 1908, tent frame cabins were built, along with a cookhouse and stable. Timber sales were given to the early Hot Springs Company, which cleared the land for expansion. Cedar logs were valued at $2 per measure in 1915, as compared to approximately $600 today. George Lippert joined the company, and in November 1916, the Everett, Schoeffel, and Lippert group incorporated and became trustees. After securing a 25-year permit for use of the land from the US Forest Service in 1917, Olympic Hot Springs was off and running.

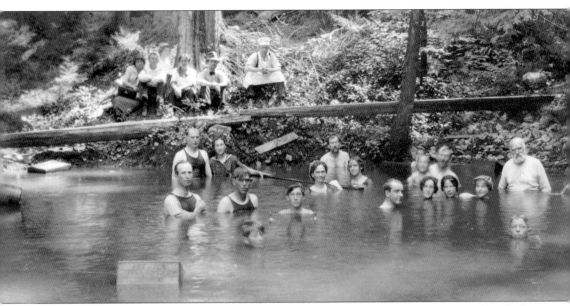

Not long after the hunting party of Billy Everett, Slim Farrell, and Charlie Anderson left the hot springs site in 1907, word of the mineral water traveled to the Elwha and Port Angeles communities. Folks came up the primitive Elwha Trail, shovels in hand, to assist with digging out this large dirt pool. Thus, the humble beginnings of a resort that would later draw thousands were made.

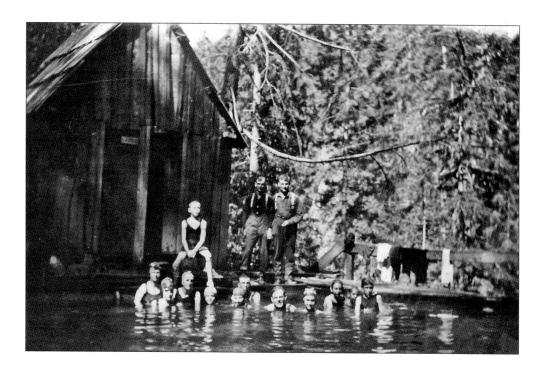

The photograph above shows the first bathhouse built on the hot springs site by Billy Everett and his wife, Margaret, in 1907. In those days, it was considered inappropriate for men and women to bathe together, even with their swimsuits on. Some photographs reveal bathers breaking the rules, however. The large pool was not deep enough to swim in, but, if men were bathing, a red cloth would be hung on a tree along the trail. If women were in the pool, a white cloth was hung. The cabin shown above contained a wood stove, a table, and two chairs. A divider wall was erected to maintain some form of privacy. In the below photograph, Maggie Everett (bottom right) enjoys the mineral water with her niece, Elsie Oxenford (left), and an unknown friend in 1907.

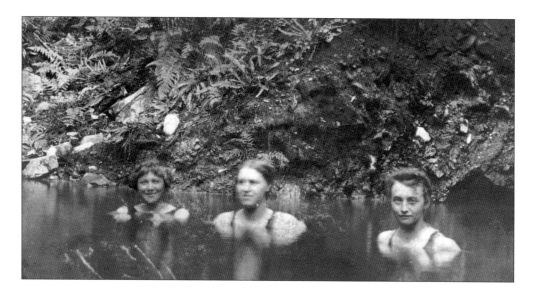

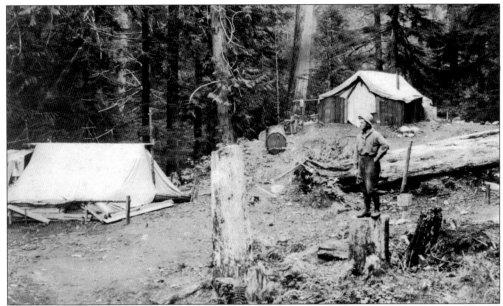

In 1908, with the warmer weather of the spring and summer months, most of the work to develop Olympic Hot Springs took place. The work crews of family and friends stayed in camp tents, such as those Karl Oxenford is seen standing near in the above photograph. The men would set out, logging the area and cutting wood with whipsaws, while the women assisted with meals and clearing smaller areas. In the below photograph, members of the Everett family pose outside of a camp tent. Shown here are, from left to right, (front) Fred and Jeanette Everett; (rear) sisters Maggie Everett, Anna Oxenford, and Lizzie Blater, with Karl Oxenford at right. Jeanette Everett is the author's grandmother.

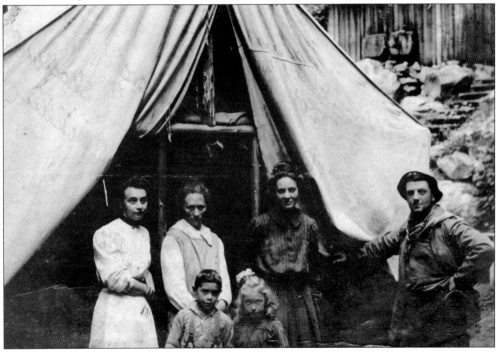

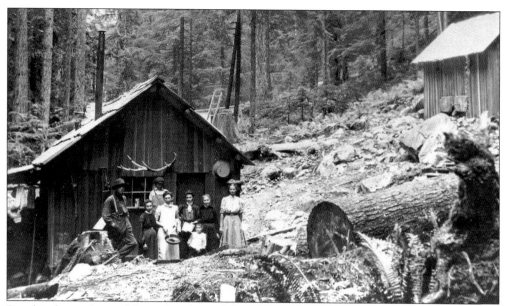

Posed in front of one of the early cabins of the Olympic Hot Springs camp in 1908 are, from left to right, (in front) Freddie Everett; (first row) Joe Sailer, Gretel Hinnebusch, Katherine Sailer, Maggie Everett, Elizabeth Schoeffel, and Katie Sailer (Elizabeth's granddaughter); (in back) Joe Sailer Jr. (Elizabeth's grandson). Elizabeth Schoeffel is the mother of Hinnebusch, Katherine Sailer, and Maggie Everett.

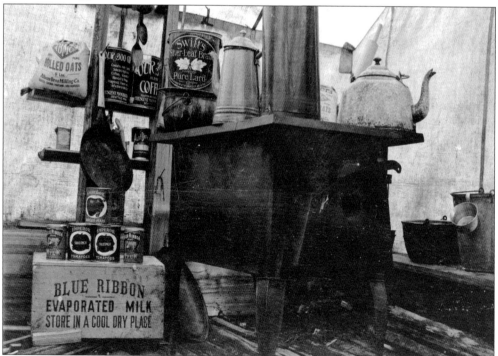

This wood cook stove includes all the necessities for a great breakfast at the hot springs camp. This stove, along with many other heavy items, came up the Elwha Trail by horse in the years before the road was built.

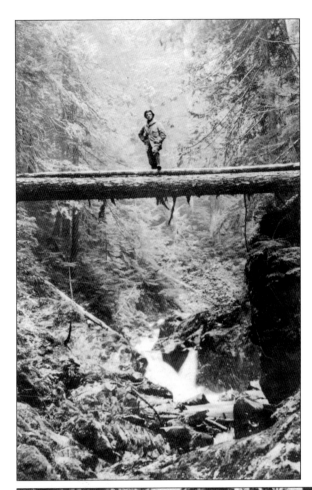

Shown here are two of the three bridges built across Boulder Creek Canyon. The left photograph, taken in 1908 by Grant Humes, shows Karl Oxenford on the first bridge, in the south end of the hot springs site. Humes, who lived about eight miles south of Olympic Hot Springs, enjoyed taking photographs of his industrious neighbors. The bridge that replaced the first span, see in the below photograph, was built by the US Forest Service, Harry Schoeffel, and the Clallam County Road Department. The three collaborated on building the road to the resort in 1930, and the Schoeffels invested large sums to maintain the road over the years.

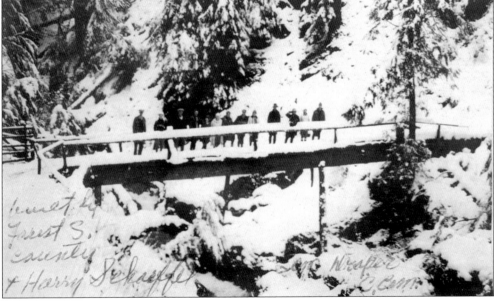

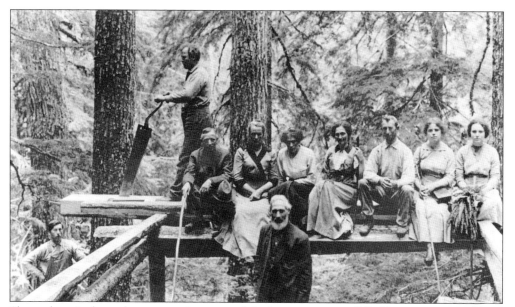

Shown here is the early construction crew of the hot springs site. Billy Everett is just visible in the lower left of the image, and Karl Oxenford is holding the whipsaw. Karl Schoeffel is third from the right, and Maggie Everett is fourth from right. Schoeffel became the third owner of the resort in a partnership formed by Everett and George Lippert in 1913. This photograph was taken in 1908, before the sawmill was brought up the following year.

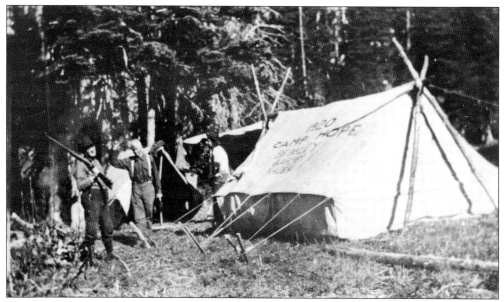

These campers are seen somewhere along the Elwha Trail. This may be part of the Mountaineers expedition that came through the area in 1920. The words on the side of the tent read: "1920 Camp Hope, Brinkley, Garber, Nadeau."

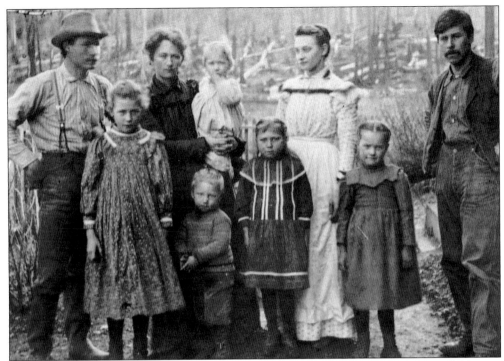

The Oxenford and Everett families worked together for many years on their farms and Olympic Hot Springs. The children were part of the work teams. Though the work was hard, the families were devoted to one another, and their integrity came forth in the lives of their children. Shown here are, from left to right, (first row) cousins Lucy Blater, Frank Oxenford, Elsie Oxenford, and Jean Everett; (second row) Karl Oxenford, his wife, Anna, holding baby Joe, Anna's sister, Maggie Everett, and her husband, Billy, the famed cougar hunter. Little Jean would later go on to marry Harry Schoeffel, her first cousin, and they would manage the resort from 1921 to 1966. Jean owned the resort for 42 years.

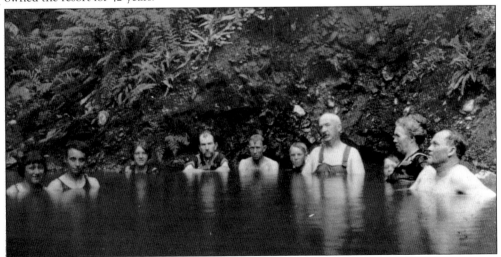

Some recognizable faces appear in this 1907 photograph of the early earthen pool. Shown here are, from left to right, Elsie Oxenford, Maggie Everett, unidentified, "Slim" Farrell, Karl Schoeffel, and five unidentified persons.

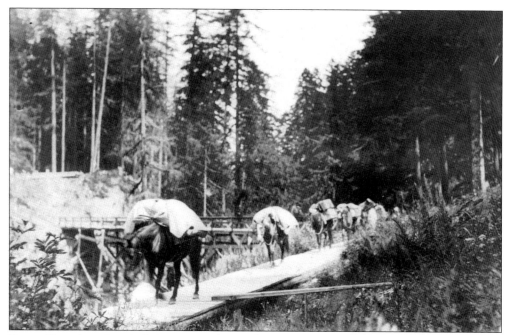

Dewey Sisson's pack train brings in supplies and guests to the resort site. The animals strained to carry the sawmill in sections in 1909 and, in 1926, more wood cook stoves, mattresses, an Edison Cabinet Diamond Disc Phonograph, furniture, tools, food, glass for windows, among other items.

Here is an expense list for the early resort in 1917. Bert Herrick's or Dewey Sisson's pack train made decent wages, at 2¢ and 3¢ a pound. It is noted that the pack train was budgeted at $875, groceries at $1,594, labor at $261, and insurance at $1,500. This was a probable forecast for upcoming annual expenditures. This handwritten note was created by Everett, Lippert, or Schoeffel, partners at the resort.

In 1909, Walter Goodwin built a waterwheel, dam, and flume. The water from Boulder Creek was channeled to turn a generator wheel, which produced electricity for the hot spring site. The wheel also generated electricity for the sawmill.

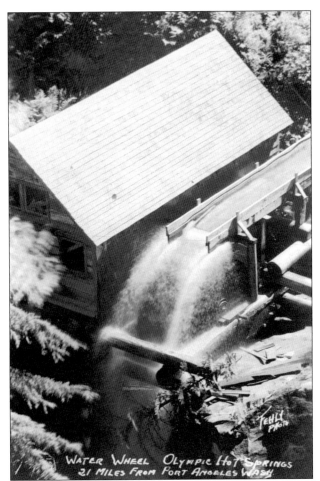

WATER WHEEL OLYMPIC HOT SPRINGS
21 MILES FROM PORT ANGELES WASH.

The flume, when clogged with tree limbs or other forms of debris, would have to be cleared out to allow the water to flow into the waterwheel and turn the generator. If a pinochle game was being played at the time the lights dimmed in and out, the loser of the game would have to hike down to the flume and clear it out.

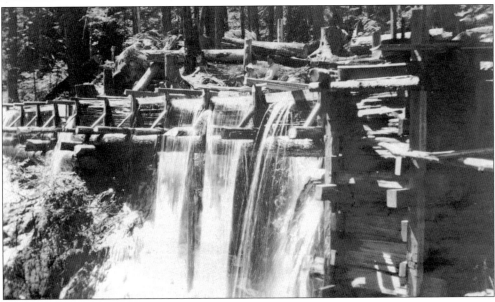

Posing at the sawmill, the "workhorse" of the growing resort, in 1910 are the future husband and wife Harry Schoeffel and Jean Everett (center), with their cousins Mike (standing at right) and Henry Hinnebusch (seated at left). Fred Peterson, in the background, was a jack-of-all-trades at the Olympic Hot Springs resort. The unassembled sawmill was brought up the Elwha Trail in sections, carried by the horses in Dewey Sisson's pack train at 3¢ a pound.

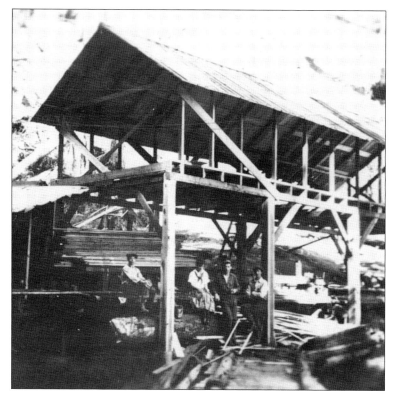

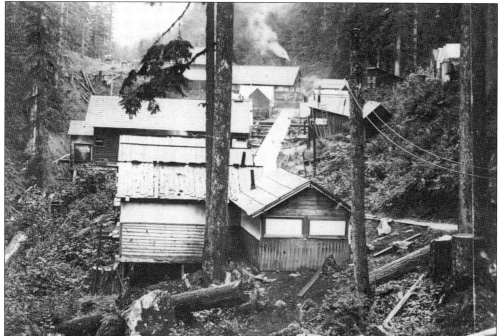

Shown here is the progress made by the Schoeffel and Everett crews after the sawmill was installed. Walter Goodwin, who installed the sawmill, is to thank for his endeavors. With an abundance of available trees, the lumber mill promoted the resort's early development.

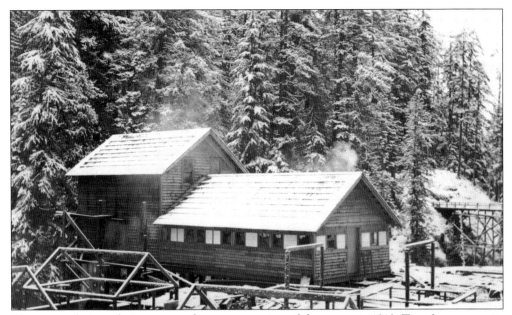

The accumulation of winter snow slows construction of the resort in 1910. Tent frames remain uncovered due to the heavy snow.

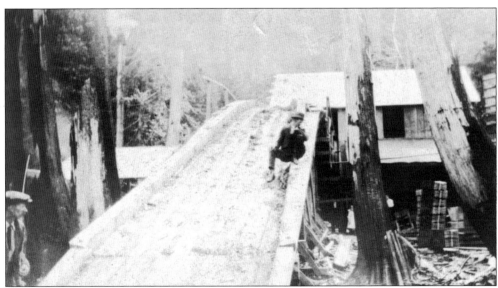

An unidentified person poses on the chute that guided the logs as they were cleared off the construction site to the sawmill. This photograph was taken in 1909.

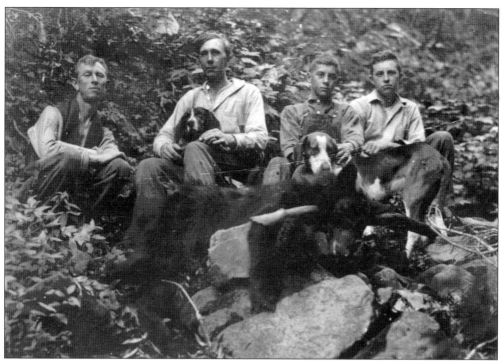

Karl Schoeffel (left), a second partner in the early years of the resort, is pictured here with Fred Peterson (second from left), a confirmed coworker and friend of Schoeffel's. They have shot a bear and are out with the hunting dogs. Also shown are Fred Everett (second from right) and his brother, Carl.

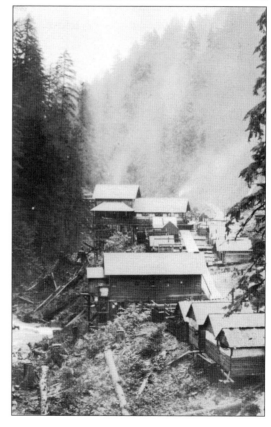

The Olympic Hot Springs complex is seen here in 1915. (Courtesy of Olympic National Park Archives.)

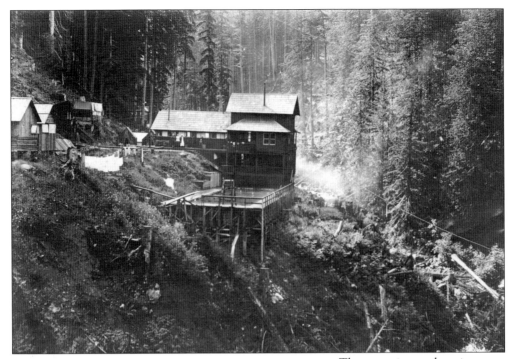

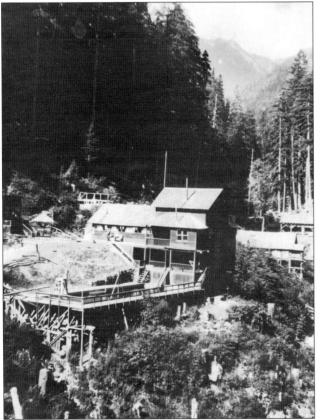

The resort is seen here in 1917, with the second wooden pool built on pilings into the hillside. It appears that the structure has molded itself into the landscape. At that time, there were no excavators to cut through the earthen obstacles deterring construction. Many things took wing in 1917. With the pool built, the Olympic Hot Springs Company started bringing in profits, and the tent cabins were full of guests during the spring and summer.

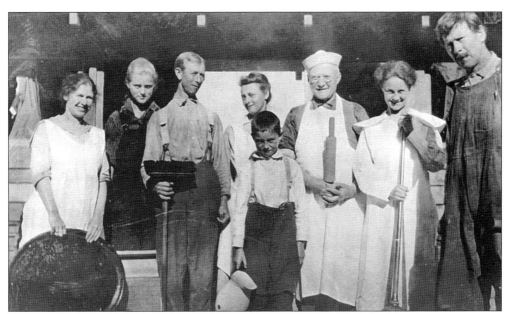

The hosts and hospitality team pose in 1917, holding brooms, tubs, and rolling pins as the tools of their trade. They are ready to accommodate their guests, who came to enjoy a wilderness retreat. Shown here are, from left to right, unidentified, Lucy Blater, Karl Schoeffel, Maggie Everett, Fred Everett (in front), unidentified, Jean Everett, and Billy Everett.

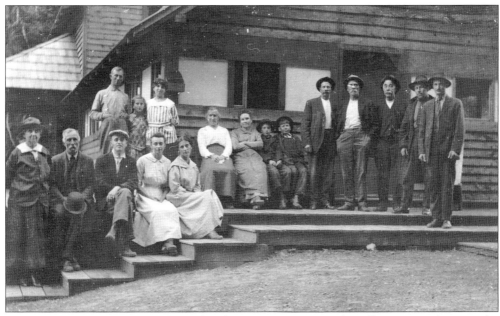

Guests, proprietors, family, and friends take a moment to pose for Billy Everett, who owned a few cameras in his time. He would pack one on his hikes about the Olympic Mountains, taking photographs of the sights while hunting wildlife. Everett would then make postcards of the images and sell them in the store.

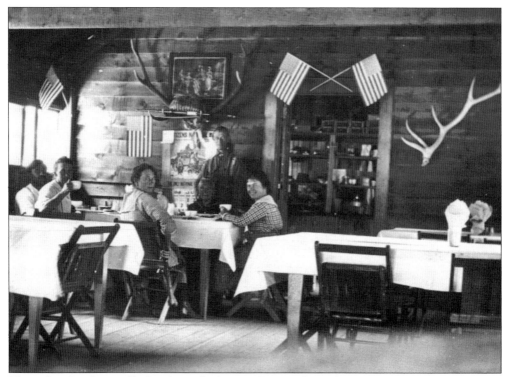

The café girls take a coffee break inside the guesthouse. Shown here are Maggie Everett (sipping coffee), Karl Schoeffel standing against the wall next to his wife, Emma, and Anna Oxenford, turning to look at the camera. The man on the far left is unidentified.

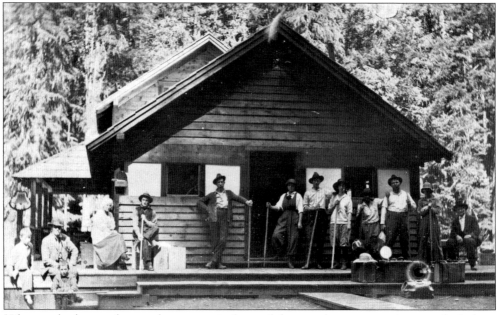

Hikers and other outdoor explorers pose in front of the guesthouse, appearing proud of where they are. They may be getting ready to conquer a peak or to catch fish in Boulder Lake, which was a steep hike above the settlement of the resort.

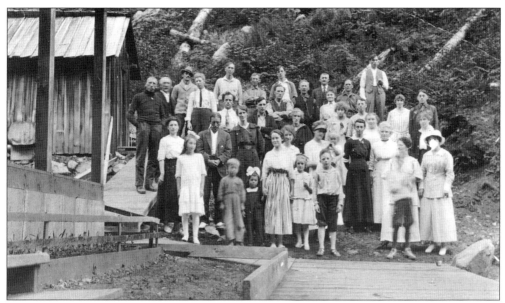

Here is a large group of folks who are family members of the owners of the Olympic Hot Springs, Schoeffel, Everett, and Lippert, while some are guests and others are staff. All in this photograph taken in 1918 participated in the success of the resort. Owner Maggie Everett is visible in a black dress (second row at right), while Heinrich Hinnebusch, her brother-in-law, is in the back row at far left with Fred Peterson (back row, third from left) and owner Karl Schoeffel (fourth from left). Owner Josephine Lippert is in the front row wearing a striped skirt. Karl Oxenford, who was another original member of the team, is seen in the fourth row, third from left, wearing a necktie. The rest of these people unfortunately are unidentified.

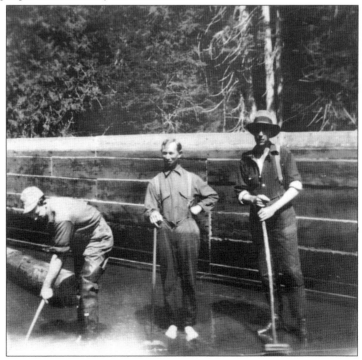

Shown here cleaning the pool are Harry Schoeffel (left), Karl Schoeffel (center), and Fred Peterson. This photograph was taken in 1917.

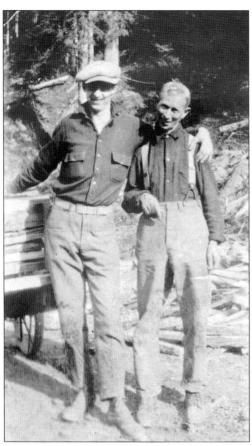

Harry (left) and Karl Schoeffel stop to pose while they are cutting wood. Woodcutting was an ongoing, everyday task. Harry bought out his uncle Karl's interest in the Olympic Hot Springs Company a few months after this photograph was taken by Billy Everett in 1920.

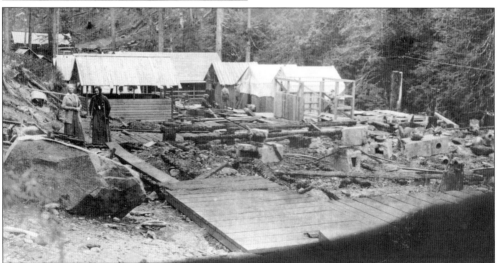

Fire struck the guesthouse in 1919. It appears that Maggie Everett, on the right side of the photograph, is on crutches, perhaps due to an injury while helping to put out the fire. Near the tent cabins, with his back to the camera, is Karl Schoeffel, who appears to be assessing the damage. With this part of the enterprise lost, the Everett and Schoeffel team planned to build the next lodge and guesthouse across the Boulder Creek Canyon.

Three

THE ELWHA TRAIL

The route to the Elwha River in the early 1900s was diverse and rough. One trail from Port Angeles went up Pine Hill heading south toward the Olympics and followed the Little River, connecting with what is now called Olympic Hot Springs Road. This road was rough-hewn and arduous. An earlier route, which many local Elwhanians refer to as the actual Old Elwha Trail, is located on the west side of the river by present-day Herrick Road.

A pony bridge that carried horses and riders was washed out in 1896. Ed Herrick, father of Bert Herrick, gathered locals to finance a bridge in 1897. In 1907, Ed Isabell and Harry Coventon built a covered bridge known as the McDonald Bridge. As progress continued, more efficient bridges were built in 1924 across from Altaire Campground. Soon after, Harry Schoeffel, owner of Olympic Hot Springs, decided to add his own pack train from Altaire to the resort. The pack train would go up to the springs and to Bert Herrick's. In the 1920s, the popularity of the resort grew, and more settlers followed the route.

Dewey Sisson offered lodging and meals at his Mountain Inn on the east side of the Elwha River from 1911 until it burned down in 1915. Sisson was the main guide and offered the main pack train service to Olympic Hot Springs until a dispute with the resort owners in 1913. Later, Herrick took over the contract from Sisson and operated a staging location from his store on the west side of the river. With frequent flooding and washouts along the Elwha Trail, the groundwork for a road was provident and forthcoming.

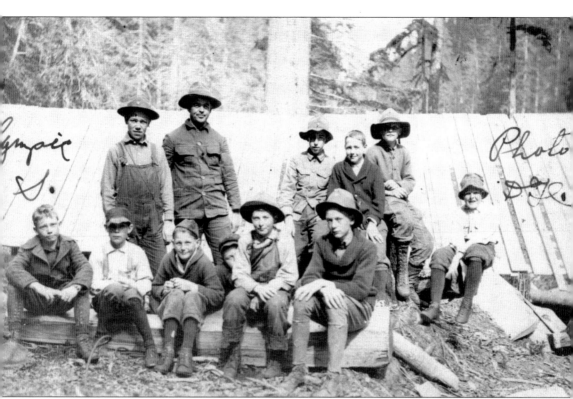

In 1916, this Boy Scout troop hiked to Olympic Hot Springs and to points beyond. The faces are remarkably clear in this photograph, but, unfortunately, the boys' identities remain unknown.

Three generations of Everetts pose atop this early bridge over Boulder Creek as the afternoon sun streams behind them. In the photograph are Maggie Everett (right), her mother, Elizabeth Schoeffel (left), and Freddie Everett.

Dewitt "Dewey" Sisson operated pack trains to Olympic Hot Springs from 1908 to 1913. In 1911, he built the Mountain Inn, with cabins facing the Elwha River. This was a layover spot for folks heading onward to the springs. Sisson was also a surveyor and wilderness guide. He was the packer and guide for Dodwell and Rixon, a team of fellows who were hired to map and survey the Olympic Mountains in 1898.

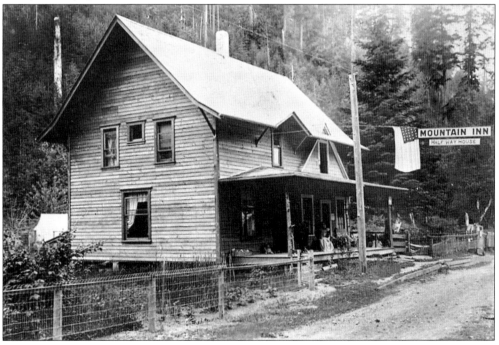

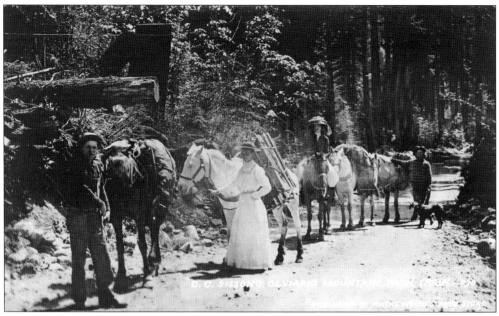

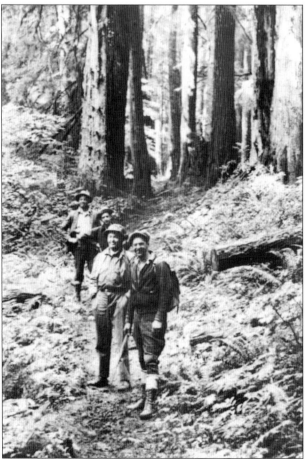

The well-known photograph above shows a group en route to Olympic Hot Springs with assistance from Dewey Sisson's pack train. Sisson is seen at the far left. The women are Maggie Everett (second from left) and her sister, Elizabeth Schoeffel; Billy Everett is on the right with his dog Babe. Apparently, the women are returning from a shopping trip into Port Angeles. Some of the items purchased are folding chairs, tied to Maggie's horse. This photograph was sold as a keepsake at the resort in the 1920s. In the right photograph, Harry Schoeffel (right) is traveling on foot under the beautiful canopy of the Elwha Trail. The men with him are unidentified.

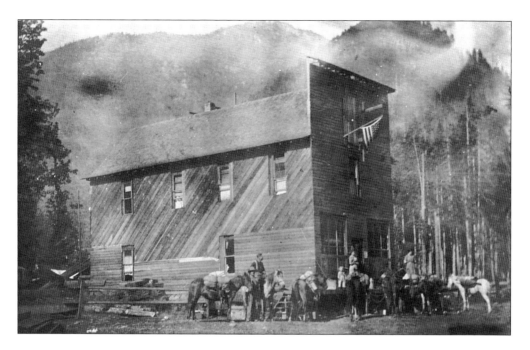

Bert Herrick's store (above) was a gathering place for local settlers to shop for goods or to catch up on the latest news of the day. Folks also came there to join the guided pack train to Olympic Hot Springs in 1910. Herrick had a colorful life with many endeavors to his name. He was a studio photographer and a land salesman, and he ran pack trains up the Elwha for 10 years. Below, a group of travelers poses for the camera before their trip up to the springs. (Above, courtesy of the Kellogg Collection.)

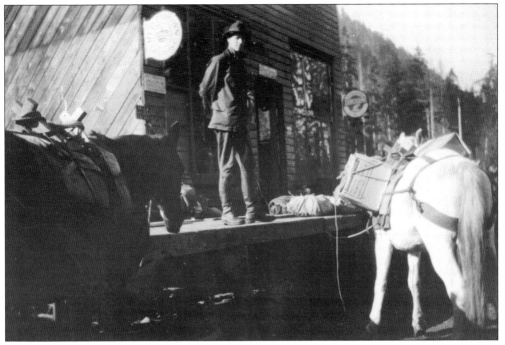

Bert Herrick poses in front of his store in 1913.

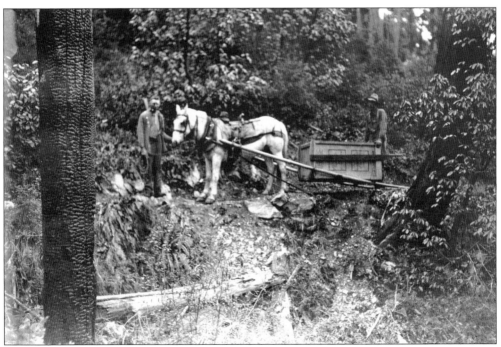

Bringing heavy items up the trail was an arduous task. Here, Fred Peterson (behind the horse) and an unidentified man lead a horse carrying a crated wood stove to the growing resort in 1915.

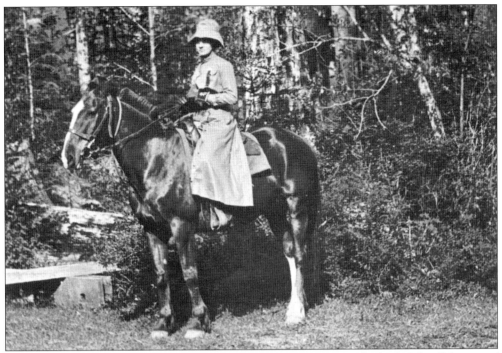

Another rider on the Elwha Trail to Olympic Hot Springs in 1912 is Elizabeth Schoeffel, sister of Maggie Everett, who married George Lippert and later Frank Blater. All the sisters, brothers, cousins, and in-laws of Maggie Everett came to assist her and Billy with construction and management of the resort.

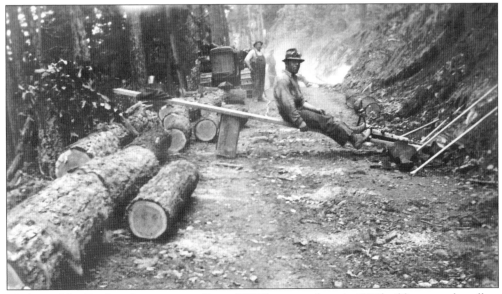

Workers of the Civilian Conservation Corps (CCC) are seen here in 1937 building a road to allow automobiles to make their way to the springs. The CCC, along with the US Forest Service and the Clallam County Road Department, joined together to build the road, which was started in the 1930s. This unidentified worker takes a break to pose for the camera. (Courtesy of Olympic National Park Archives.)

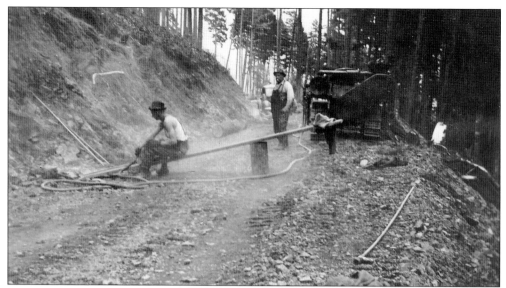

The Civilian Conservation Corps, established through New Deal legislation implemented by President Roosevelt in 1933, was intended to help unemployed people get back to work. More than 300,000 people were enrolled during the program's nine years of existence. Shelters and barracks were built to house the crews, with some along the Elwha River where the Elwha Resort used to stand. During the 1930s, many other road-building projects in America's national parks were undertaken by CCC crews. Room and board was provided to the men, and the wages, $30 a month, were sent home. (Courtesy of Olympic National Park Archives.)

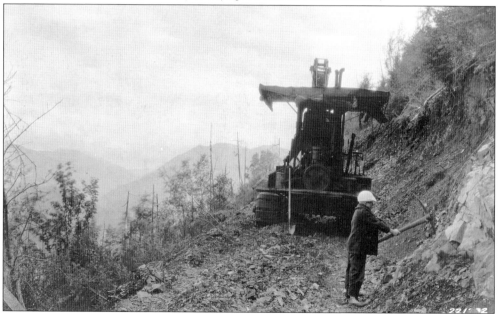

The construction of the road to the Olympic Hot Springs concluded in 1937 with access to a campground above the resort, which was also constructed by the Civilian Conservation Corps. Here is young Bobby Schoeffel assisting the workers with a pickaxe. The Schoeffels, who owned the resort, invested thousands of dollars in the road construction as well. (Courtesy of Olympic National Park Archives.)

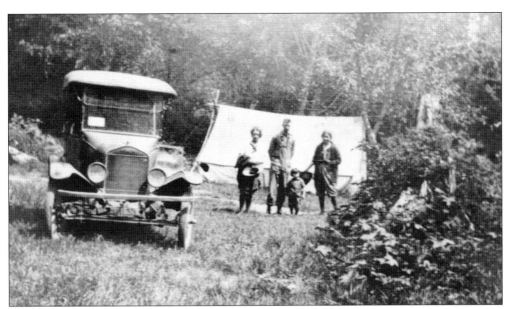

With the road open to motorists, the family in the above photograph is out on an expedition while camping on the Elwha. In 1929, there were many places to establish residence for a few days. Today, Olympic National Park has campgrounds in only two places in the Elwha area. In the left photograph, an automobile makes its way along the national park's new road, cut amid the massive trees.

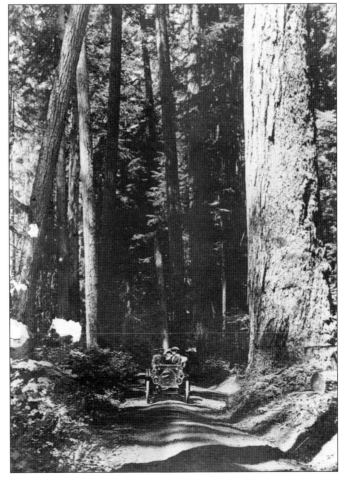

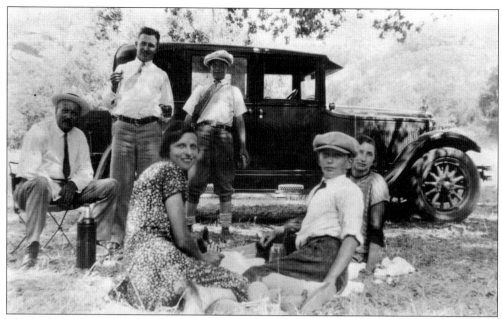

The Sailer family came from California often to spend time at the resort, as Katherine Sailer is the sister of the owners Maggie Everett and Karl Schoeffel. Seated on the ground peeking from behind her grandson Edwin Diedrich is Katherine Sailer. Seated on the ground in front is her daughter, Katie Sailer Diedrich. Seated on a stool next to the car is Joe Sailer Sr. To the right of Joe is his son-in-law, Hon Diedrich, and next to Hon is his son Milton Diedrich. They are all enjoying a picnic along the shores of the Elwha River en route to the Olympic Hot Springs in the 1930s.

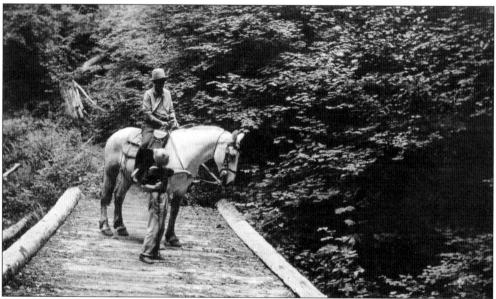

With the road open and droves of people coming to the resort in cars, Harry Schoeffel and his boy, Bobby, travel the old-fashioned way, with their horse, Pal, in 1939. Even with the availability of "speedy" automobiles, a jaunt through the steep trail to Boulder Lake riding on the back of Pal was more fun. And it beat "hoofing" it there on foot.

Four

THE TWENTIES

Following the fire to the guesthouse in 1917, another lodge was built. The resort enterprise grew, and changes came along in the 1920s. The bridges over Boulder Creek were completed, a new wooden pool was installed, cabins were built to replace the tent frames, an additional guesthouse was erected, and 2,500 feet of boardwalk were placed over the muddy ground. Many inventions of the era found their way up the winding Elwha Tail to the resort. An Edison Victrola phonograph, the latest cameras, an electric wringer washing machine, electric lightbulbs, and a pedal sewing machine came up on the Herrick pack train. Electricity had become common, but many of the facilities still heated and cooked with wood.

In early 1920, Prohibition commenced. Gangsters were marauding loudly about in the big cities in the East, yet at Olympic Hot Springs, the grinding of the sawmill making lumber was the sound of hearty prosperity. With deeper cooperation with the US Forest Service, the Olympic Hot Springs Company had an exciting future and had little issue with procuring leases and permits from the government.

Harry Schoeffel joined in the operation of the resort in 1919. He later took over his uncle Karl Shoeffel's interest and married Everett's daughter, Jean, in 1921. Schoeffel had a jovial personality, and many of his cousins found him immersing himself in the duties of the resort. The 1920s brought good business to the growing enterprise, but the reopening of the Sol Duc Hot Springs in 1921 resulted in a decline in visitors. With the Everett and Schoeffel team anticipating the completion of the road, the trail still brought many interesting guests for the spring and summer seasons.

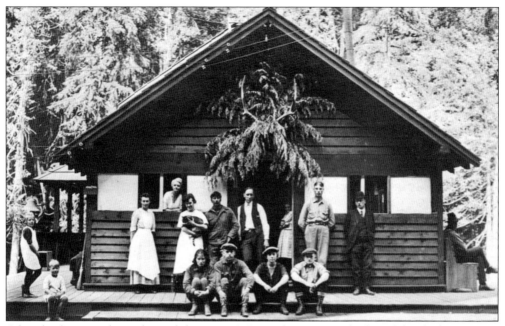

After the first guesthouse burned down in 1917, another one was built and finished in 1918 or 1919. Among those identified in this photograph are Maggie Everett (standing left of the window) and Mrs. Soff, who helped in the kitchen (in the window). Jean Everett is holding her bobcat, Oscar, who lived to be 22 years old and weighed close to 28 pounds. Next to Jean is her father, Billy Everett, owner of the resort, and next to him is Fred Peterson, who worked years for Billy. The rest are unidentified.

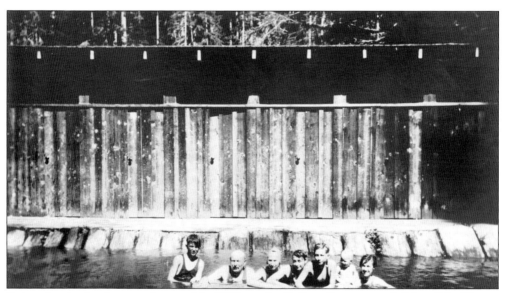

Swimming in the first wooden pool in 1927 are the Sailers, Everetts, and Schoeffels. Shown here are, from left to right, Milton Diedrich, Joe Sailer, Katherine Sailer, Maggie Everett, Edwin Diedrich, baby Bobby Schoeffel, and his mother, Jean Everett Schoeffel. The Sailers, big fans of Olympic Hot Springs, came up from California on many occasions.

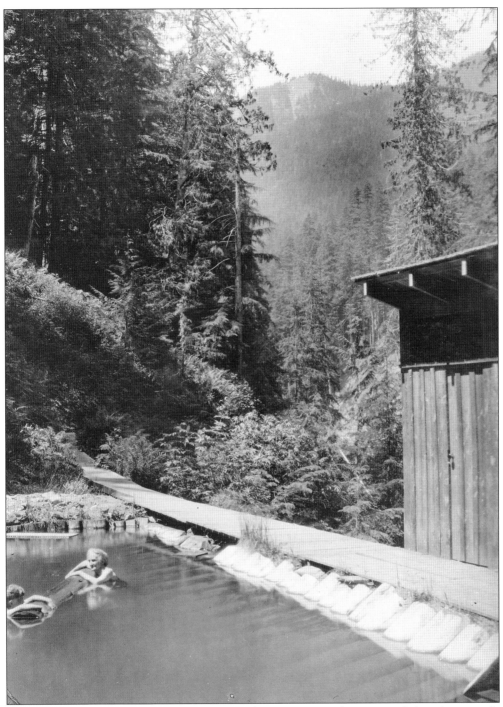

The first pool was a pond without containment, but in 1910, wood was cut and planed to encircle the pond, and it became the first wooden pool at the resort. A second pool was constructed down the hill in front of the lodge in 1917. The second pool would leak and need repairs, so the early pool was used often in place of the larger, newer one. In this photograph, an unidentified woman is enjoying the warm water of the first pool, which held temperatures up to 108 degrees.

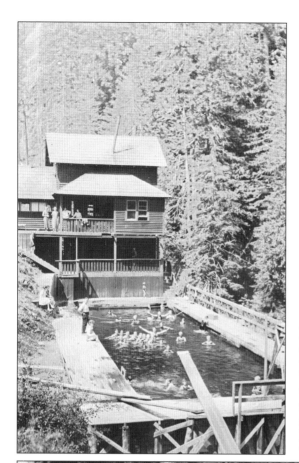

Four years after the second pool was constructed at 75 long and 25 feet wide, the first Port Angeles Swim Team comes to have a day in the large wooden pool in 1921. It is not known if the water in this pool was a mixture of mineral water and fresh water from Boulder Creek. The photograph below was taken by Neil Mortiboy in 1921.

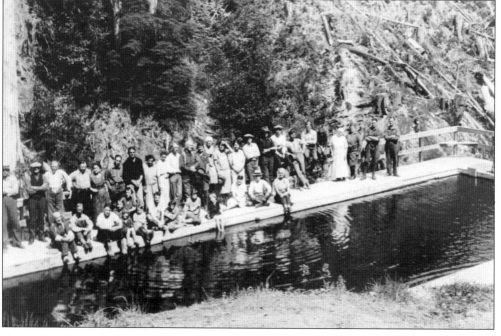

Here, a Fourth of July celebration includes a pie-eating contest. The day also featured a footrace across the 100-foot-long bridge and a sack race to boot.

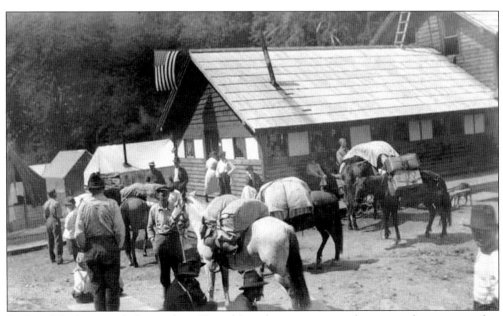

In this 1917 photograph, horses from Herrick's pack train arrive at the springs, bringing supplies and weary guests. New arrivals were anxious to get into the hot mineral water and soak away the aches and dust from traveling the long trail. (Courtesy of Clallam County Historical Society.)

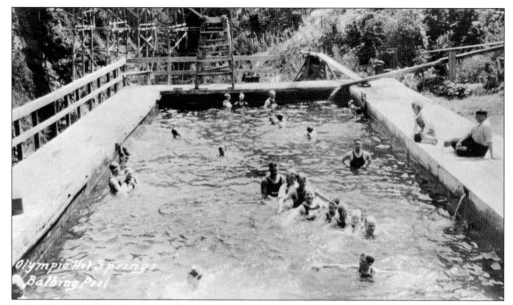

In this photograph, happy guests swim in the wooden pool in the early 1920s. (Courtesy of the Kellogg Collection.)

Karl Schoeffel, one of the owners of the resort, carries his niece, Nellie Hinnebusch, wearing her bathing suit, in a wheelbarrow down the boardwalk from the upper pool. Her children, Vera and Barney Hinnebusch, tag along.

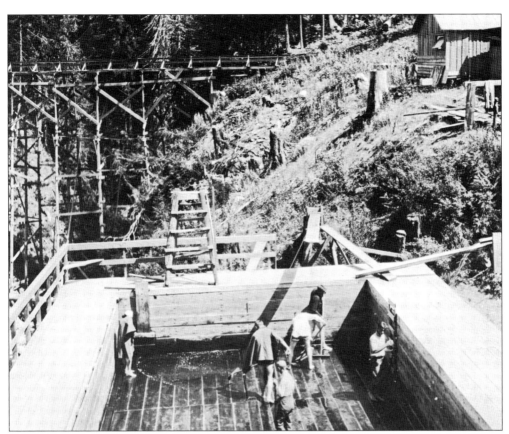

Along with the recreation and fun, life at the Olympic Hot Springs resort involved work. In the above photograph, workers are draining and cleaning the pool. The mineral water would create a slimy substance on the surface of the wooden pool, making it slippery. This pool was said to leak, and continual patching was among the work duties. Karl Schoeffel (front center) seems to be directing these young men about their task in 1921. Every resort needs a cook, and the unidentified man in the right photograph must have been Olympic's. Many of the guests would bring their catch of the day from Boulder Lake or meat from the hunt, and the cook would prepare it for them.

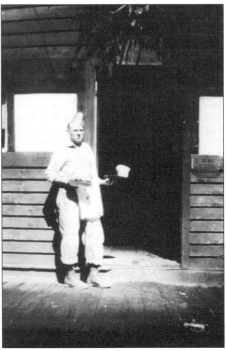

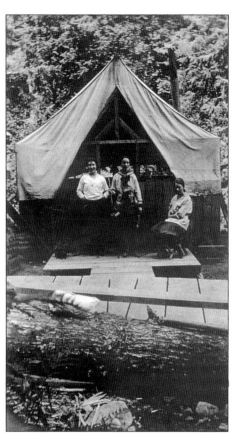

The tent cabins were spacious and much appreciated by the hikers and travelers who came up the trail and were in need of rest and healing water. The women and child in this photograph are unidentified.

These guests were staying in one of the tent cabins in 1917. The man brought along his ukulele to serenade the pretty women posing here with him.

Billy Everett, with his rigorous work schedule, takes time out to get a haircut by a friend. His wife, Maggie, may have taken the photograph while admiring her husband through the lens.

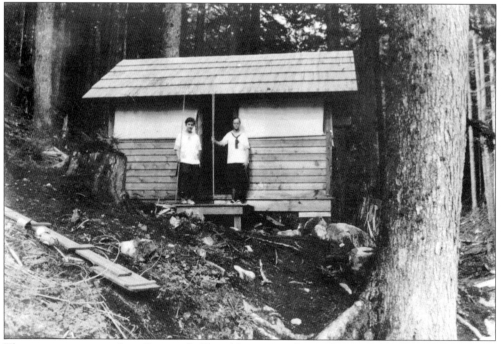

These young women, Jean Everett (left) and her cousin Lucy Blater, pose in front of one of the early cabins being built in 1916.

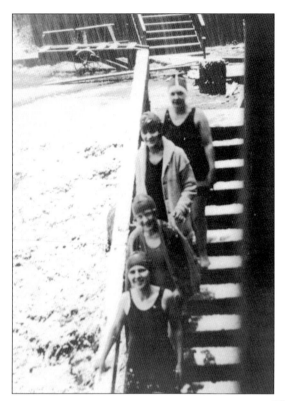

In the left photograph, Jean Everett (second from the top of the stairs), with unidentified women, ventures out in the snow to swim in the warm mineral water in 1919. The water, with temperatures reaching over 100 degrees, must have been worth braving the chill of winter. The women of Olympic Hot Springs were doted on by the matriarch, Elizabeth Schoeffel (below). While in her 80s, she came to assist her daughters while they worked at the resort. Elizabeth had been a midwife in earlier years. Maggie Everett, who owned the resort, was her youngest child, so Elizabeth stayed with her, helping where she could. Elizabeth, who lived to be 88, enjoyed her family and life at the Olympic Hot Springs resort.

This is a formal portrait of Karl Schoeffel, Maggie Everett's brother, who bought into the property of the Olympic Hot Springs Company in 1914. He came from Mount Vernon with his wife, Emma.

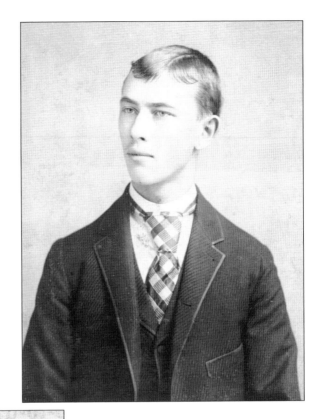

Carl Shoffel Sells Interest Olympic Springs

Carl Shoffel, for fifteen years part owner with Billy Everett in the Olympic Hot Springs, has sold his interest to his nephew, Harry Shoffel. Carl has been inseparably connected with the Olympic Hot Springs in the minds of all who have visited the place, and all who have gone to the springs during months outside of the regular season have particularly pleasant memories of the hospitality of "mine host."

Carl is in town until Saturday, when he will return to the springs. He will continue to take an interest in the place which he has helped so much to build up. Later he plans to visit his sisters in California for part of the winter.

This newspaper article describes the departure of Karl Schoeffel, who sold his interest in the resort. In 1919, Karl was thrown from an automobile and injured, but he recuperated and went back to work at the springs.

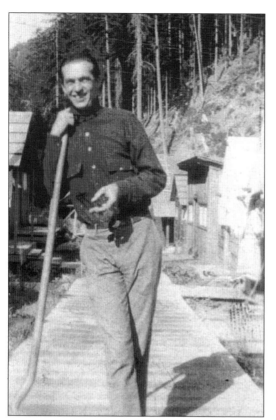

Harry Schoeffel came to the hot springs in 1919 and fell in love with the place. His love for life and laughter made him the perfect host, to the benefit of the thousands of guests he entertained over the years as proprietor.

Harry Schoeffel takes the hands of his favorite cousins, who have come to stay for the summer. Shown here are, from left to right, Harry Schoeffel, George Schoeffel, Henry Hinnebusch, and Mike Hinnebusch. Henry stayed on with the resort for years, but his brother Mike went back East and became a priest. The Hinnebusch boys also stayed with their father, Heinrich Hinnebusch, who lived in the Freshwater Bay area next to his sister-in-law Maggie Everett. Heinrich and Gretel Hinnebusch had 10 children.

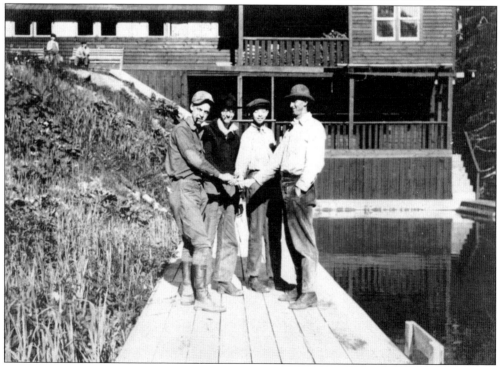

Jean Everett and Harry Schoeffel, who started falling love, are seen here in 1920 with mud streaked on their legs and arms. It looks like Jean wins this contest, shoving Harry in the pool.

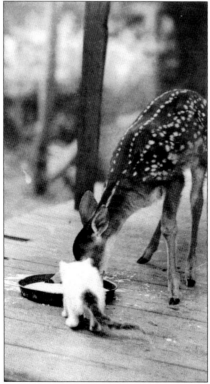

Humans were not the only ones who made friends at the resort. Here, a fawn that became a pet around the grounds shares a bowl of milk with a kitten. Two fawns that had lost their mothers became members of the resort family.

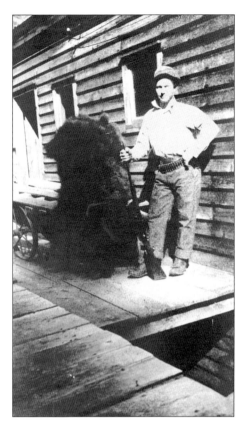

While some animals were adopted as pets, others were hunted. Such was the fate of this bear, taken down by this unidentified hunter at the hot springs. The bear may have been a pest in the resort area, as was the case with many bears that came lurking about.

With the resort's growth, crews worked at clearing a site for the new hotel on the west side of Boulder Creek. The location of the new lodge was across the canyon from the previous one, which had burned down in 1917. After logging, this 1919 photograph shows two unidentified men atop a stack of waste to be burned. The relocation site was recommended by the US Forest Service to, in theory, further protect the mineral springs by moving the lodge to the other side of the creek.

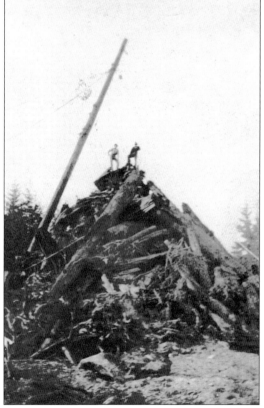

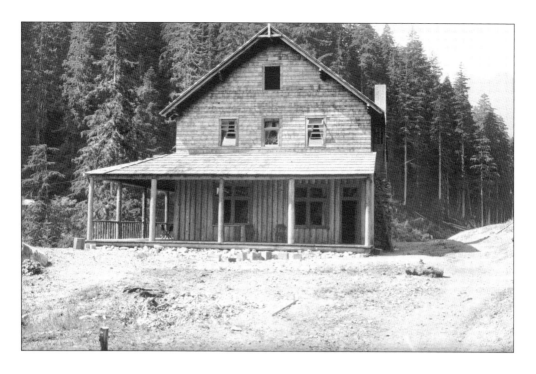

These 1923 photographs show the new hotel that was scheduled to open in spring of 1924, yet it met an unfortunate fate that winter when heavy snow caused the roof to collapse. Nonetheless, the determined Everett and Schoeffel team started again, and the hotel was completed in 1926. Both photographs show the lodge near completion.

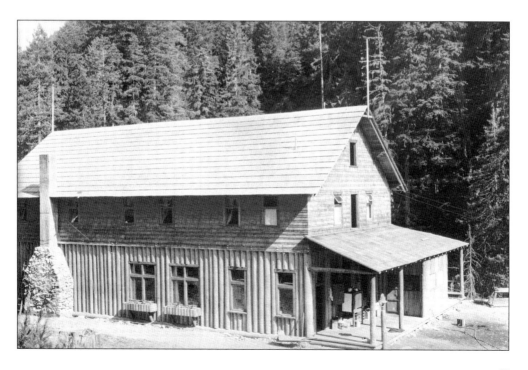

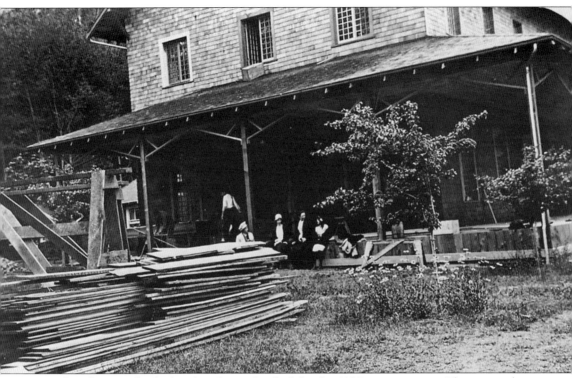

In this photograph, the hotel is almost finished for the 1926 tourist season. The women have returned from a function in town, as they have hats on and appear to be wearing dress clothes. Perhaps they went shopping, purchasing necessary items to furnish the new hotel. (Courtesy of the Kellogg Collection.)

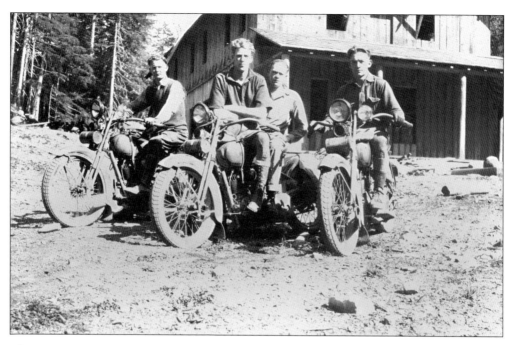

These men came up the Elwha Trail while the road was under construction by the joint effort of the CCC and Clallam County. The unidentified men, on 1923 Harley Davidson dirt bikes, may have been part of the construction crew for the new hotel, or they may have come just to see what was going on.

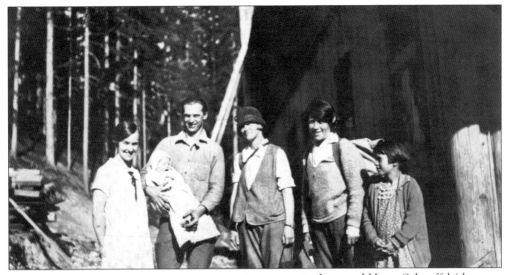

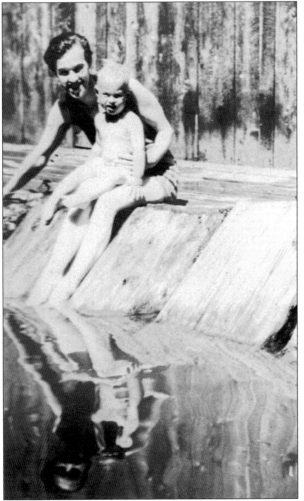

Jean and Harry Schoeffel (the couple at left) bring a new addition to Olympic Hot Springs with the arrival of their son Bobby Schoeffel after taking ownership from Jean's parents, the Everetts. They are photographed here with cousins Lucy Blater (center), Elsie Oxenford (right of center), and little Vera Hinnebusch in 1926. Lucy Blater was know to pack a gun in case a grouse would fly by.

The first pool, built in 1910, was used intermittently while the other pools were in repair and while the big cement pool was being constructed in 1930. This photograph of Jean and baby Bobby Schoeffel was taken in 1927, when the larger wooden pool was either being cleaned or repaired. Located in a more secluded area, this pool was a sanctuary from the crowds. Remnants of this pool were intact for decades after the resort closed.

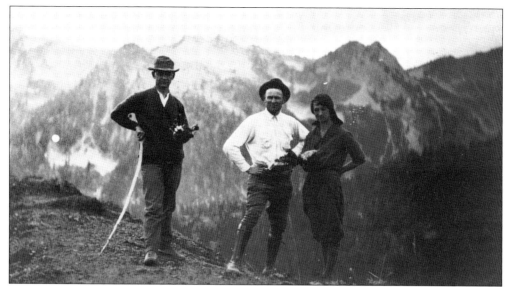

Many nature lovers and hardy outdoorsmen and women were attracted to the beauty of the Olympics. After a long day of hiking, a soak in the mineral pools at the resort lured the best of them. In this photograph are Antone Schoeffel (left), father of proprietor Harry Schoeffel, with two unidentified persons. They have climbed to the top of Crystal Ridge, Schoeffel doing so while in his early 60s.

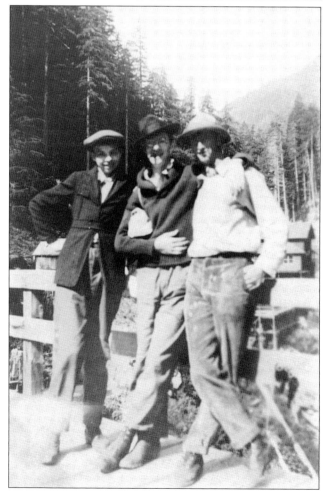

A group of guys called the "Three Musketeers" stayed at the hot springs resort for continuing summers in the early 1920s, working and palling around with Harry Schoeffel. This group played and worked hard at the resort, forging a bond as cousins. Shown here are Henry Hinnebusch (left), Mike Hinnebusch (center), and cousin George Schoeffel in 1917.

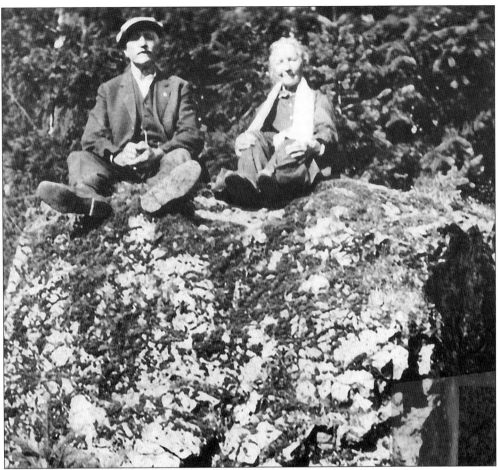

Seen here in 1922 are Heinrich Hinnebusch and Elizabeth Schoeffel, seated on a large rock that was lodged along the Elwha Trail close to the Olympic Hot Springs camp. The two, mother-in-law and son-in-law, were the matriarch and patriarch of two large families. Heinrich came out West from Pittsburgh when his wife, Gretel, died to ranch in the Port Angeles area near his family at Freshwater Bay. Heinrich and Elizabeth between them had 17 living children spanning two generations. Heinrich, a sturdy, large man, married Elizabeth's daughter Gretel in 1882, and they had 10 children. He came out to the Olympic Peninsula, bringing four of his sons, after her death. Both Heinrich and Elizabeth were on hand at the hot springs, assisting with duties. Heinrich, a stonemason, trained his sons to help with much of the cement work at the resort.

Five

HARRY AND JEAN SCHOEFFEL

Jeanette Everett was born and raised in Port Angeles, Washington, to William and Margaret Everett of Freshwater Bay in 1895. During her teen years, she went to school by way of her horse, 12 miles into Port Angeles. Jeanette went on to college at Pacific Lutheran University, where she joined the ladies' basketball team. She was employed in a china shop as a ceramic painter in Tacoma while she went to college. She was raised at Olympic Hot Springs and on the family ranch in Freshwater Bay. Her mother, grandmother, and aunts all came out West to the Olympic Peninsula from Germany in the late 1800s. Her uncles stayed in the East, in the Pittsburgh area. Her father, Billy Everett, was an only child and was of native S'Klallam origin, and Jeanette's mother, Maggie, was the youngest of nine Schoeffel children. Jeanette married Harry Schoeffel, her cousin on her mother's maiden side, in September 1921. Jean and Harry Schoeffel, who had one child, managed the Olympic Hot Springs resort for 43 years. She died after Harry did in 1986, and both are buried in Port Angeles.

Harry Schoeffel was born in 1895 and raised in the Pittsburgh area. He had an older sister named Edna and a younger brother named Fritz, both of whom stayed in Pittsburgh. His parents, Antone and Elizabeth, stayed there as well. Harry, who came out West to Olympic Hot Springs in 1919 after being discharged from the Army, worked for his aunt Maggie Everett and his uncle Karl Schoeffel and ended up operating the resort with Jeanette until 1966. Harry hiked and went fishing, and he loved his Old Crow whiskey and Panatela cigars. Jean and Harry were the hosts of the resort and managed it for 43 years. They had a son, Bobby, who died in Port Angeles in 1989. They have six grandchildren and nine great-grandchildren, all of whom still live in the Port Angeles area.

Jean Everett (left) is pictured as a young girl with an unidentified cousin in 1898.

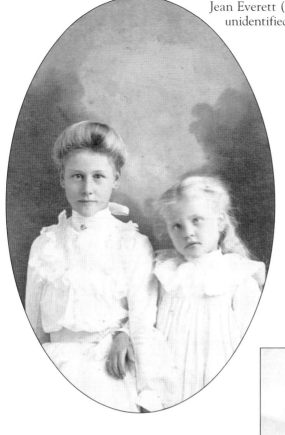

Jean, in her basketball uniform, poses for her college photograph in 1915. She played the guard position, and her team was quite good. Jean was away at Pacific Lutheran University for almost two years when called home to help work with the family.

Carl Everett, Jeanette's brother, took control of the ranch while his parents were at Olympic Hot Springs. Carl, who never married, spent some time working as a telephone lineman. He inherited the Everett ranch when his parents passed away; his sister Jean received the resort with her husband, Harry.

Jean poses at the homestead at Freshwater Bay near Port Angeles after logging took place. Jean, a lover of the outdoors like her parents, would go off on expeditions with her mountaineer father, Billy Everett. Note the gun on her lap.

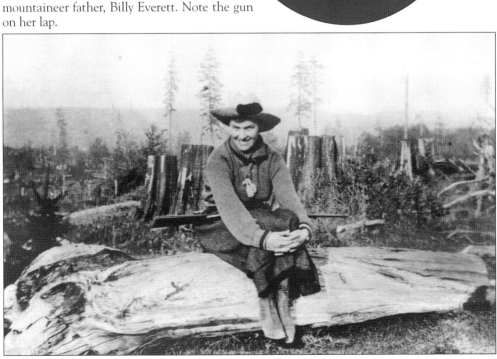

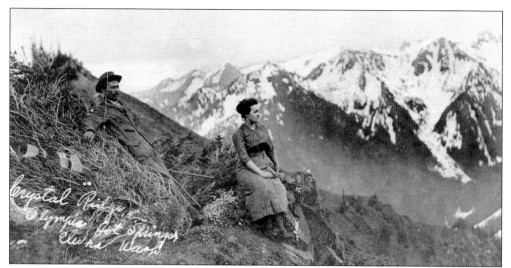

Jean and Billy Everett take in the view on Crystal Ridge, overlooking the Olympic peaks, in 1914. When Billy packed a camera, Jean would carry the rifle.

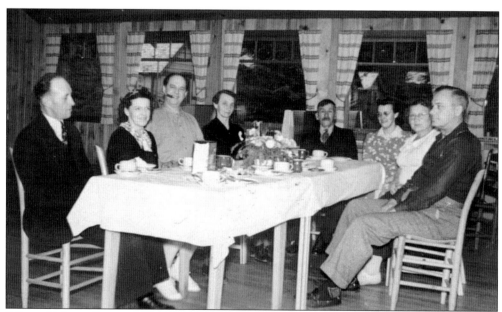

Billy and Maggie Everett celebrate their 50th anniversary in 1943 at Olympic Hot Springs' dining room with an intimate dinner with their children. Seated around the table from left to right are Carl Everett, an unidentified woman, Harry Schoeffel, Maggie Everett, Billy Everett, Jean Schoeffel, and an unidentified woman and man. Earlier there had been a traditional wedding ceremony for the couple at the Lutheran church in Port Angeles with over a hundred guests in attendance.

Seen here is Harry Schoeffel's family in Pittsburgh in 1900. Elizabeth Schoeffel sits at top with Fritz; Edna, the oldest child, and Harry are seated below.

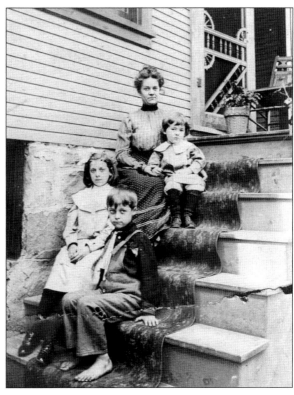

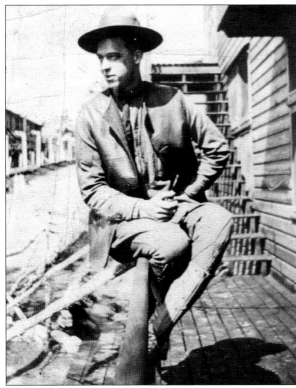

This 1915 photograph shows Harry Schoeffel at Camp Gordon.

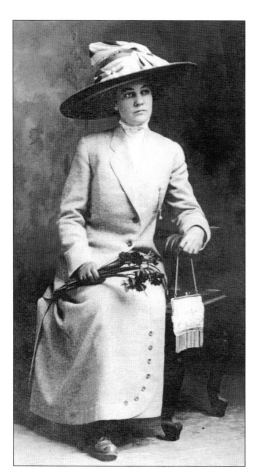

Harry's mother, Elizabeth Stemmich Schoeffel (left), came out West a few times with her husband, Antone, to stay with her son and assist with operations at Olympic Hot Springs. Antone Schoeffel (below) came from Germany in the late 1800s along with his three brothers, and they settled in the Pittsburgh area.

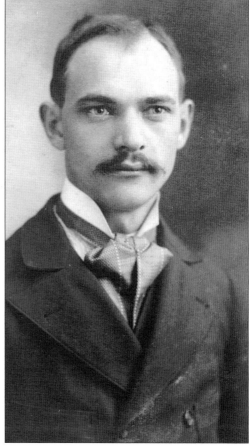

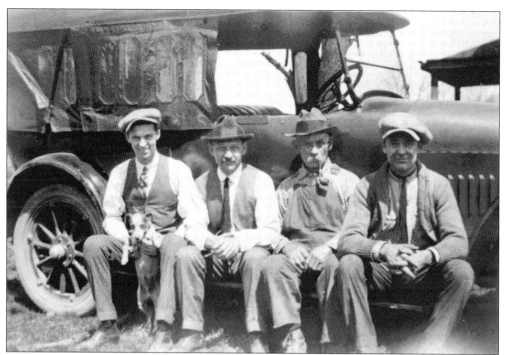

In this 1914 photograph, Harry Schoeffel (far right) poses with his father, Antone (second from right), his uncle Adam (second from left), and his brother Fritz.

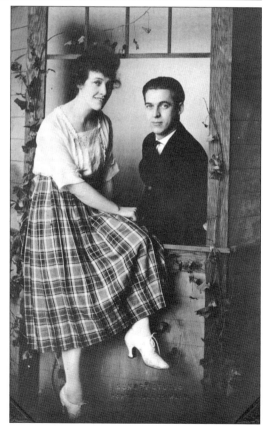

Harry and Jean were wed in Victoria, British Columbia, in 1921; they were married for 65 years.

Maggie Everett holds her only grandchild, Bobby Schoeffel, in 1926.

Bobby Schoeffel is home on leave from the Navy in 1943 to see his family. Jean and Bobby were photographed while taking a drive around Lake Crescent.

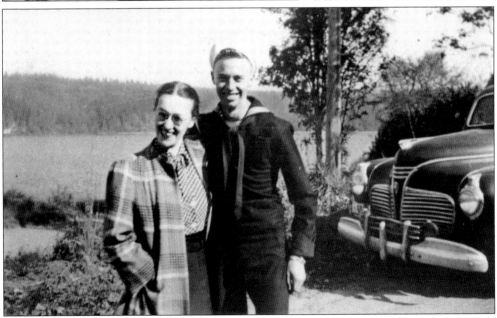

Six

THE BOOMING THIRTIES

With the completion in the 1930s of the road up to Olympic Hot Springs from Highway 101, the resort was brimming with guest reservations. The new lodge was finished in 1926, and a large cement pool with a row of dressing rooms on each side was built. The construction materials were brought up the winding 12-mile road by E. Anderson Construction of Port Angeles, which built the pool in the late summer of 1930. In September 1930, Helene Madison, holder of 26 swimming records, came to dedicate the new pool. Helene went on to win three gold medals in the 1932 Olympic Games in Los Angeles, California.

With additional investments, the Everett and Schoeffel families started construction in the late 1920s, which carried on into the early 1930s. The generous guest amenities included 12 guest rooms in the new lodge, dining services, a store, long-distance telephone service, private mineral baths, and furnished cabins overlooking the pool and Boulder Creek. Guided pack trips with horses were available, with a campground nearby. The reputation of the resort was spreading, and business was thriving.

There were visits from notable and famous people, including Princess Martha and Prince Olav of Norway in 1939. Zane Grey, the author of Western novels, stayed a week in 1932, and his son Von Romer attended years later. The singing movie star of the late 1920s, Jeanette MacDonald, stayed for three days. Other guests included the Von Trapp family, portrayed in the movie *The Sound of Music*, and Pres. Franklin Roosevelt's daughter, Anna Boettinger, who found her way there when Roosevelt came out in 1937. These are a few of the famous guests, but surely, all visitors found fun and repose in the beauty of the Olympic Peninsula and amid the generous hospitality found at Olympic Hot Springs.

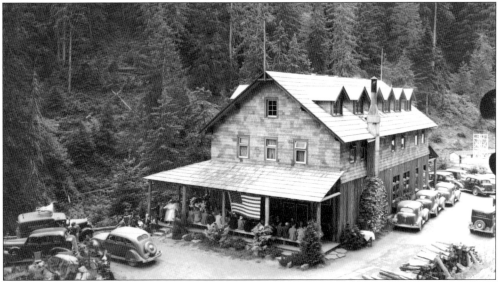

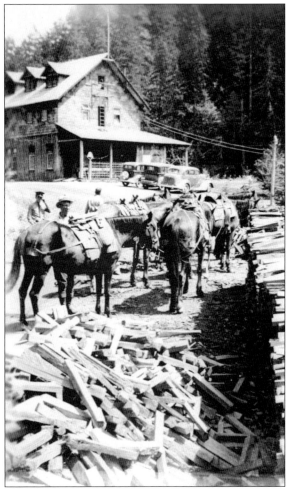

The new lodge was completed and full of guests in 1930. The rustic flavor appealed to all who came for a touch of modern with a sense of camping. The long-awaited road came right up to the front door of the handsome hotel. There were 12 sleeping rooms for guests, and in the dining room, meals were served family-style. There were private baths; if preferred, a tub of mud to draw impurities from the skin could be used. There were 28 furnished cabins, some with views of the new pool and 12 that overlooked Boulder Creek. There was a bathhouse at the south end of the pool with dressing rooms along both sides. (Photograph by Neil Mortiboy, courtesy of Helen Payne.)

Bert Herrick's pack train continued to bring supplies and guests to the resort. He also gave guided trips into the hills. The wood supply was kept well stocked, as all the cabins had wood cook stoves. Herrick's horses had to become acclimated to the automobiles going by them, as both forms of transportation had to share the road.

Shown here is the new pool, 40 feet by 120 feet, which was finished in the fall of 1930. It was quite the construction project, 21 miles from Port Angeles. With the new pool, the resort was booming with business. This was good news for the Schoeffels, as the construction cost for the pool exceeded $30,000, and it would take many more roaring summers to break even from so large an investment. E. Anderson, who was 60 at the time, and his son Arnold, 26, finished the construction in early September 1930, and gold medal swimmer Helene Madison, from the Washington Athletic Club in Seattle, was invited to dedicate the pool on September 20.

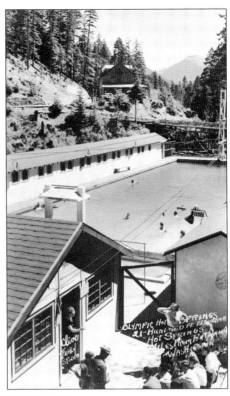

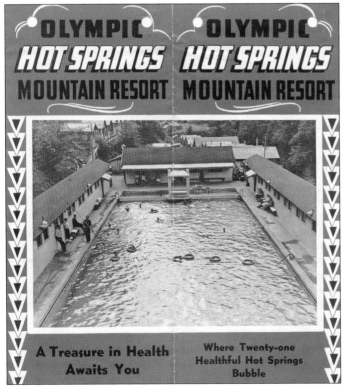

This bright-red brochure was created to promote the resort in the 1930s.

M	Olympic Hot Springs

IN ACCOUNT WITH

E. ANDERSON

GENERAL CONTRACTOR

BUILDINGS, BRIDGES, CONCRETE WORK, SEWERS, GRADING AND EXCAVATING
ESTIMATES PROMPTLY FURNISHED

1930		Cement-	G & S.-	Misc.-	Truck-	Shovel			
July	21	To Hauling		3 yd					
	23	4000ft. lumber			6 Hr				
	24	4500 " "			6½				
	25	Mixer			8				
	26	Piling Gravel	3½		5	2 Hr.			
	27	Steel			6				
	28	"			6				
	29	"			6				
		Piling Gravel				2			
		Placing Mixer					2.00		
	30	Hauling Steel			6				
	31	" "			6				
Aug	1	" "			6				
	2	4000 ft. Lumber			6				
	4	Hauling		7½					
	5	" & Shovel		4					
	6	"				4			
	7	"				2¾			
	8	"				4			
	9	"				8			
	11	"				8			
	12	"				10			
	13	"				10			
	16	"	120 Sck	4					
	17	"	100 "						
	18	"		3					
		" Trough and Forms			5½				
	19	"	100		350 lbs				
	20	"	100	3½					
	21	"	100	1					
	22	"	306		850 "				
	23			3½	500 "				
	25	"		4					
			826 Sck	37 yds	1700 lbs.	73H	50½ H.	2	00
	To	Hauling 826 Scks Cement @ 13 Cts				107	38		
		" 37 Yds Sand & Gravel @ 3.50				129	50		
		" Lime, Paint etc 1700 lbs @ 13 cts				2	21		
		Use of Truck 73 Hours @ 3.00				219	00		
		" Shovel 50½ " @ 3.12½				157	81		
	" Balance rendered August 1'st 1930					503	31		
	" Account of Personal Services Eric Anderson					500	00		
						1625	21		

According to E. Anderson's itemized accounts, he delivered over 4,000 feet of lumber and 826 sacks of cement for part of the pool construction, which was scheduled to be completed by Labor Day, 1930. Anderson is also attributed with building the Lee Hotel, the Lincoln movie theater in Port Angeles, the newspaper building, and the Eagles Temple in the 1920s.

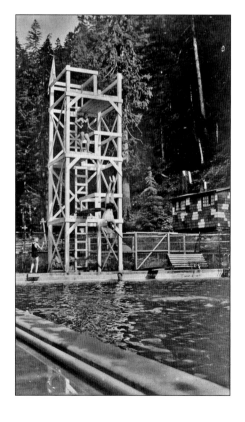

Seen here is the diving tower as it appeared in early 1930. The three-level tower was eventually removed after someone dived off the highest level, which was over 30 feet, and hit his head on the bottom of the pool. The tower was sawed off, landing in the pool.

A Port Angeles newspaper article announces the appearance of Helene Madison, world champion swimmer. She came with a team of aquanauts to dedicate the new pool at Olympic Hot Springs. Madison went on to win three gold medals in Los Angeles in 1932. (Courtesy of *Port Angeles Evening News*.)

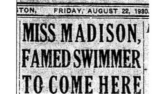

TON, FRIDAY, AUGUST 22, 1930.

MISS MADISON, FAMED SWIMMER TO COME HERE

HELENE, RAY DAUGHTERS AND OTHER NOTED FIGURES TO BE GUESTS AT LUNCHEON IN PORT ANGELES SEPTEMBER 20.

IS PUBLIC AFFAIR

Will Dedicate Olympic Hot Springs Pool With Exhibitions Later in Day

Olympic Peninsula admirers of Helene Madison, famous Seattle girl swimmer, who holds six world's championships, will have the opportunity of meeting and watching the young miss in action soon.

This was made known today by Harry Schoeffel, proprietor of the Olympic Hot Springs, and G. C. Field, Seattle, architect, who designed the new pool and accompanying features now being constructed at the Springs.

According to plans now being worked out, Helene Madison, Ray Daughters, her equally noted coach, and a group of other acquatic aces from Seattle will come to Port Angeles on Saturday, September 20. They will be honor guests at a public luncheon sponsored here by the Chamber of Commerce at noon. Early in the afternoon they will motor to the Olympic Hot Springs.

At the mountain resort the swimming marvel and her companions will help dedicate the large, new concrete pool that is rapidly being completed there. Afternoon and evening exhibitions of swimming and diving will be given to thrill and entertain the hundreds expected to assemble at the place.

Flood lights will illuminate the pool for the evening performance.

Helene and her party will remain at the Hot Springs over Saturday night until Sunday and possibly will "do their stuff" on that day. They plan to return home Sunday, as the girl must be at school Monday morning. Despite all her laurels and world-wide fame, she still is a regular school girl and must not let anything interfere with her education.

Accompanying Miss Madison on the local trip will be her mother, Ray Daughters, her coach, and his wife; Neva Brownfield, well-known swimmer and diver; Jack Medica and Frank Whalen, also top-notch water aces; Guy Sherwood, proprietor of the Crystal Pool, with his wife and daughter, and Mr. and Mrs. G. C. Field and two daughters. It is through friendship of long years with Sherwood that Field is enabled to bring the group here.

If weather is favorable, Helene and Whalen will fly to Port Angeles on the morning of September 30. The remainder of the party will leave Edmonds for Port Ludlow on the ferry at 8:30 a.m., motoring to this city.

The Chamber of Commerce yesterday readily offered its services

(Continued to Page Two)

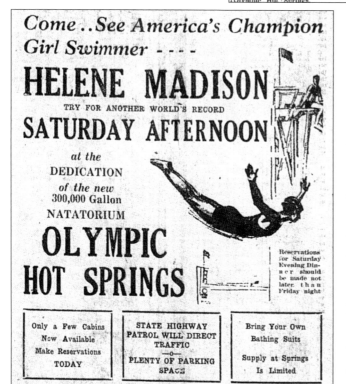

Come.. See America's Champion Girl Swimmer - - - -

HELENE MADISON

TRY FOR ANOTHER WORLD'S RECORD

SATURDAY AFTERNOON

at the

DEDICATION

of the new 300,000 Gallon

NATATORIUM

OLYMPIC HOT SPRINGS

Reservations for Saturday Evening Dinner should be made not later than Friday night

Only a Few Cabins Now Available Make Reservations TODAY	STATE HIGHWAY PATROL WILL DIRECT TRAFFIC —o— PLENTY OF PARKING SPACE	Bring Your Own Bathing Suits Supply at Springs Is Limited

A Port Angeles newspaper advertisement announces the Helene Madison exhibition and pool dedication at Olympic Hot Springs. Madison lived in Seattle and was sponsored by the Washington Athletic Club as a teen. Her coach, Ray Daughters, guided Madison to 26 records and three gold medals. She danced with actor Clark Gable at the Coconut Grove in Los Angeles the night she won the gold at the Olympic Games in 1932. (Courtesy of *Port Angeles Evening News*.)

85

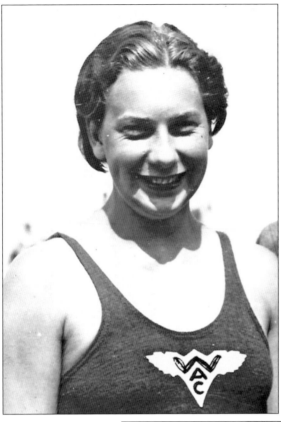

This is a photograph of a young Helene Madison during the 1932 Olympics. The Port Angeles newspaper covered the exhibition at Olympic Hot Springs when Helene came to dedicate the pool with fellow swimmers. Coach Ray Daughters was impressed with the buoyancy of the water, stating that, in the pool's mineral water, "Helene could break any record in the world." There was a great party after the exhibition, with a banquet in the lodge and Helene dancing with the guests afterward. Harry and Jean Schoeffel were commendable hosts to the record-breaking crowd.

These news stories tell the events of September 20, 1930, when the world-famous swimmer came to perform. The Washington State Patrol directed the traffic on the way to the resort, as there were cars along the roadside for miles. The new road had just been completed that spring. (Courtesy of *Port Angeles Evening News.*)

HELENE BREAKS WORLD AND U.S. SWIM RECORDS

HELENE KEEPS UP ASSAULT ON RECORD BOOKS

GIRL CHAMPION WILL TRY TO BREAK WORLD'S RECORD FOR 40-YARD BACKSTROKE AT POOL DEDICATION.

WATER WILL BE PUT IN NEW POOL NEXT SATURDAY

Jean Schoeffel is seen here with her baby, Bobby Schoeffel, in 1927. Jean has Bobby perched on the railing of the bridge, which was 80 feet high and spanned 100 feet across Boulder Creek Canyon. Bobby was noted for daredevil antics performed in his later years at the resort, including buzzing the guests in the pool with his airplane in the early 1950s.

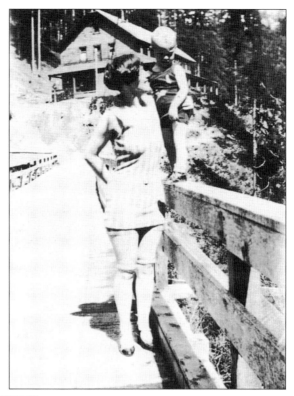

The hillside around the resort was saturated with mineral water coming up from the ground. A cement rock wall was built to secure the embankment by this man, Mr. Lazarski, at a cost of $1,500 in 1938.

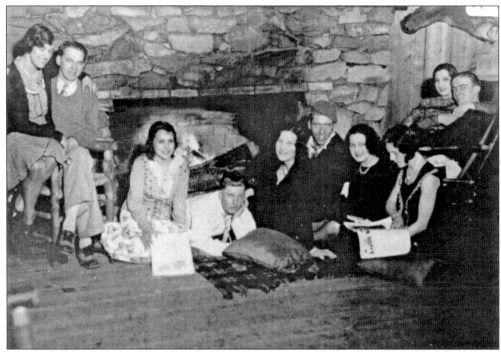

Newlyweds Harry and Jean Schoeffel, on the far right, gather with friends in the lodge during a party in 1930. The Schoeffels were the new owners of the resort. (Courtesy of the Kellogg Collection.)

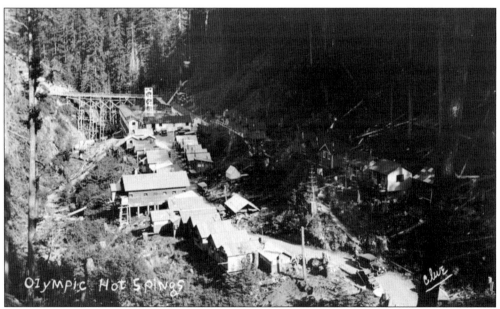

The sprawling resort is seen here in 1930. There were added cabins and buildings, as well as a bathhouse and pool area. The new lodge is across the bridge, on the west side of the bench. (Courtesy of the Kellogg Collection.)

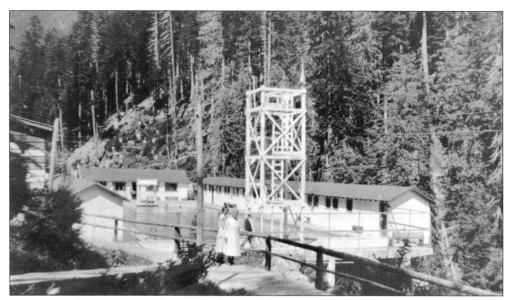

The new pool area is seen in this 1932 photograph.

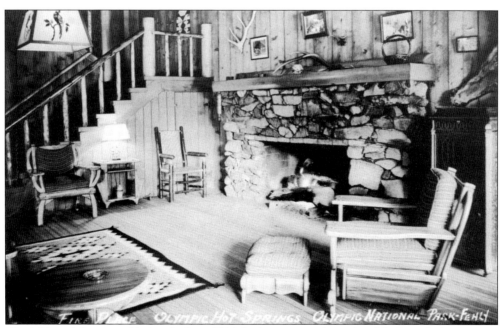

The lobby of the second lodge, built in 1926, looks rustic and comfortable. It took the Everetts and Schoeffels six years to build the lodge, due to a few winters with heavy snow that caused the construction to cave in. With a cabinet Edison Diamond Disc player in the lobby and over 800 lights in the facility, guests could have fun throughout the night, including enjoying music and Chautauqua performances by the talent found about the resort.

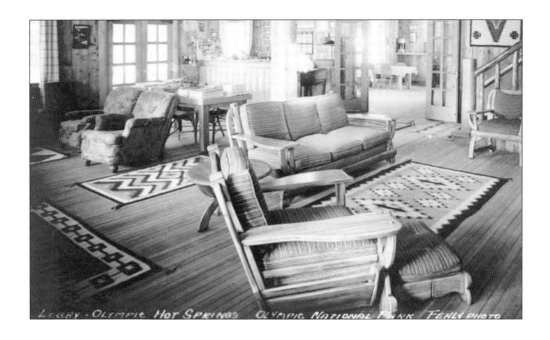

These photographs show the lobby of the main lodge in 1930. Lodge rates were $4.50 per day and $28 per week, and this included meals, private baths, long-distance telephone service, and swimming. (Above, courtesy of Clallam County Historical Society.)

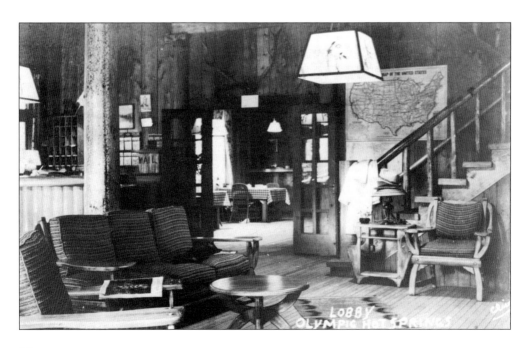

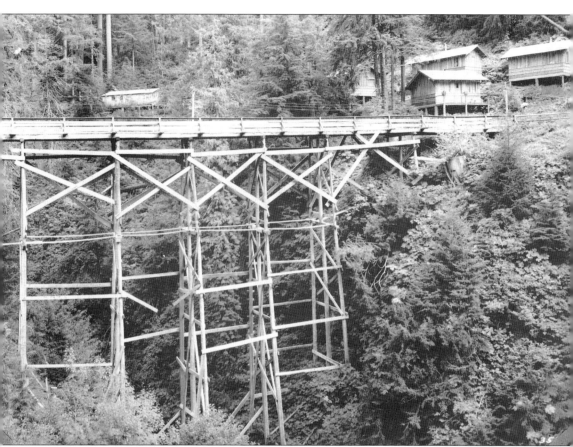

This bridge over Boulder Creek, built in 1917 by Billy Everett and Ben Owens, took patrons from the hotel on the west side to the cabins and pool area. The bridge was 80 feet high and over 100 feet long.

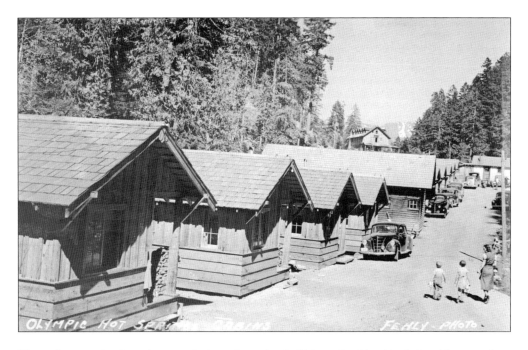

These photographs show the row of cabins along the shelf above Boulder Creek. In addition, cabins were tucked in on the surrounding hillsides and overlooked the resort. Cabins were furnished with wood cook stoves, beds, toilets, and sinks. The interior walls were mostly paneled in knotty pine. A campus store sold most items that a guest would need, including ice for refrigeration. Cabins rented for $2 a day or $9 a week in 1930.

This is another photograph and postcard that was sold at the resort. The owners advertised that the "modern resort" included mail and taxi service from Port Angeles. Some housing for the staff was in the third floor of the lodge. In some cases, staff members would share a cabin. There were additional staff quarters in the "Slab," below the pool, which had rows of windows looking out to Boulder Creek.

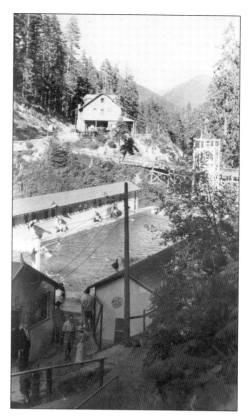

In this photograph, an unknown woman befriends a fawn at the resort. It was not uncommon for such forest friends to visit the staff that stayed during the summers.

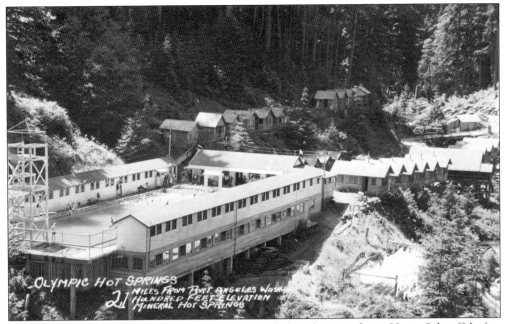

This photograph was taken by Clive Fehly, who sold his photographs to Harry Schoeffel after they were made into postcards. Harry would then sell them at the resort.

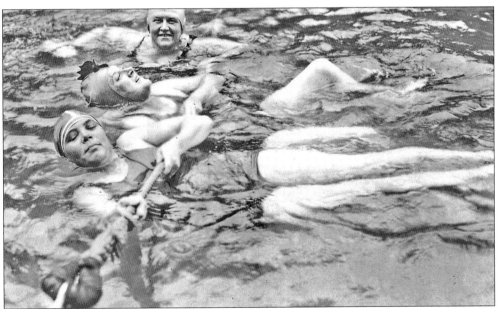

The lady swimmers pulling on the rope in the middle of the pool are having a great swim in 1932. In the center is Vineta Cauvel. (Courtesy of Marie Cauvel.)

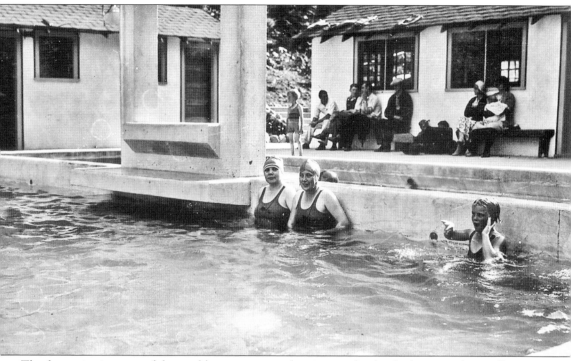

The front viewing area of the pool has two women leaning on the divider between the smaller pool, which was hot with mineral water, and the larger pool, which remained a perfect 80 degrees. (Courtesy of Marie Cauvel.)

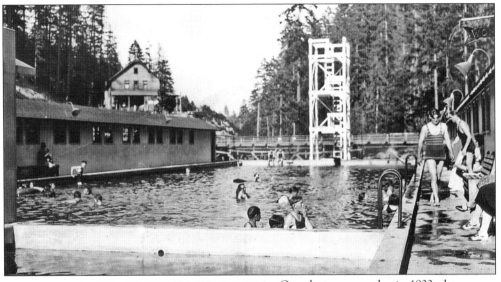

On a hot summer day in 1933, the pool is full with a "swirl" of swimmers. (Courtesy of Marie Cauvel.)

Olympic Hot Springs Hotel Burns Down Saturday, Loss Estimated At Over $10,000

STRUCTURE CATCHES FIRE ON SECOND FLOOR AND BURNS TO GROUND IN AN HOUR.

The three-story hotel at the Olympic Hot-Springs was completely destroyed by fire last Saturday causing a loss of approximately $10,000, partially covered by insurance, according to a report from Fritz Herrick, caretaker.

Harry Schoeffel, manager and one of the owners, is at Wampum, Pennsylvania, where his parents, Mr. and Mrs. Antone Schoeffel celebrated their Golden Anniversary. Mrs. Schoeffel and their son Bobby are also at Wampum.

In telling of the fire Herrick said they heard a crackling noise upstairs while himself, his father Bert Herrick and the housekeeper, Mrs. Annie Elban had just finished eating breakfast in the kitchen at about 8:30 o'clock Saturday morning.

An attempt was made to get up stairs to fight the fire but the heat was so intense and smoke so thick it was impossible to do anything. The fire started, Herrick declared, in Harry Schoeffel's room on the second floor through which a chimney is built.

The interior of the building was built almost exclusively of cedar lumber and fire spread very rapidly and it was only possible to save some small articles on the main floor. The entire building burned down in an hour. There was very low pressure in the water at the hotel and it was of little use in fighting the fire.

Besides the furniture that is in the hotel in the summer months bedding and furniture from many of the tourist cabins was stored in the building and was also a total loss.

The hotel stood alone east of the hot springs proper and the rest of the camp was not endangered by the blaze as Boulder creek separates the two units of the establishment.

Olympic Hot Springs Hotel Burns Down

(Continued From Page One)

eral winters. He sawed the lumber for the edifice in the small water-power mill that was there and in some instances hewed out the giant timbers that were used in it. The construction was semi-rustic with rustic furniture used in many cases. There was a huge fireplace made from bolders in the main room of the lodge and a winding stairway leading from the main floor to upstairs. On the second floor were guest rooms and above them were quarters for the help. A covered porch extended the full length of the building on the south side.

Many trophies gathered by Mr. Everett and family during a period of many years, decorated the main room. There was a modern refrigeration system in the kitchen and a large dining room.

The building was completed before the road was built to the Hot Springs and its construction entailed months of hard labor. It is predicted that another like it cannot be built under modern conditions.

The amount of insurance is not known until Mr. Schoeffel returns from the east and an adjustor visits the scene. Three firms in this city, representing various insurance companies, had written policies on the building.

The loss of the hotel, while being a great one, will not hinder the operation of the resort. There are more than 30 tourist cabins, a store and huge swimming pool intact across Boulder creek.

This Port Angeles newspaper article describes the fire that destroyed the hotel in January 1940. While the Schoeffels were away, the fire started on the second floor through the chimney, according to the caretakers. With the lodge made almost entirely of cedar, which burns rapidly, the fire consumed the building in about an hour. The loss was estimated at $19,000, according to the owner, Jean Schoeffel. Among the lost items were photographs, many of which might have been used in this book. With the rest of 1940 ahead of them, Harry and Jean Schoeffel rebuilt. The resort reopened in the spring with the construction of the third lodge in progress. (Courtesy of *Port Angeles Evening News*.)

Seven

CHANGES FOR THE FORTIES

The booming business in the 1930s brought many notable figures to Olympic Hot Springs, including movie stars, authors, gold medal swimmers, political officials, and even Norwegian royalty. It also brought the introduction of Olympic National Park, which annexed the resort in 1938. President Roosevelt visited in 1937 and assessed the land before it was placed under the jurisdiction of the national park system. This new authority forced Jean and Harry Schoefflel to accept many changes to their business operations. In January 1940, a fire swept through the lodge. The three-story structure, which took six years to construct, burned to the ground in less than an hour. Only the chimney from the lobby fireplace survived.

The Schoeffels went on to build a third lodge, adding to the existing bathhouse adjacent to the pool. They added a second story with rows of large windows, a lobby store, a dining room, and living quarters. The resort endured many challenges in the 1940s, but reservations continued to filter in, and guests would continue to visit for many seasons to come.

BY THE PRESIDENT OF THE UNITED STATES OF AMERICA

A PROCLAMATION

[No. 2380—Jan. 2, 1940—54 Stat. 2678]

WHEREAS the act of June 29, 1938, (ch. 812, 52 Stat. 1241), established the Olympic National Park in the State of Washington, and authorizes the enlargement thereof by proclamation under the terms and conditions set forth in said act; and

WHEREAS it is deemed advisable to add certain lands as hereinafter described to the said park; and

WHEREAS the terms and conditions of section 5 of the said Act of June 29, 1938 have been fully complied with:

Now, THEREFORE, I, Franklin D. Roosevelt, President of the United States of America, under and by virtue of the authority vested in me by section 5 of the aforesaid act of June 29, 1938, do proclaim that subject to all valid existing rights, the following described lands, in the State of Washington, are hereby added to and made a part of the Olympic National

Shown here is a portion of the declaration by President Roosevelt annexing land to create Olympic National Park in 1936.

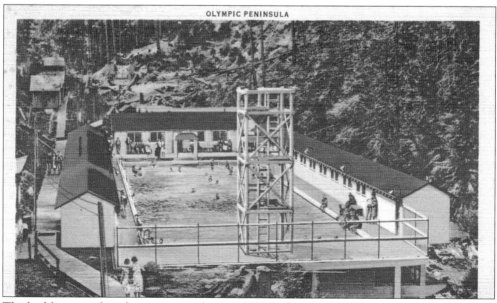

The bathhouse and pool area are seen here in 1938, before the hotel fire in 1940.

98

Following the fire in 1940, this advertisement, printed in *Sunset Magazine*, revealed the newly constructed lodge, built later that year. A new "music box" was brought in at a cost of $219 to entertain guests, and according to a 1941 purchase order, a new water wheel cost $700. An invoice reveals that $270 was spent for advertisements in the *Seattle Times* in 1942.

The company spent more than $1,000 for advertising in Seattle newspapers to announce the reopening of the resort. This postcard shows off the new lodge, built in 1941. With the increase in business, the Schoeffels hired more lifeguards. Willis Gormley and Dale Brusseau of Port Angeles were brought on board to tend to the men's dressing rooms.

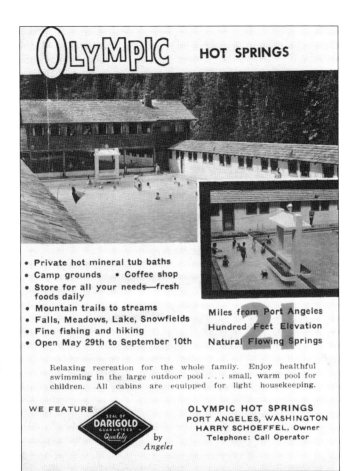

OLYMPIC HOT SPRINGS

- Private hot mineral tub baths
- Camp grounds • Coffee shop
- Store for all your needs—fresh foods daily
- Mountain trails to streams
- Falls, Meadows, Lake, Snowfields
- Fine fishing and hiking
- Open May 29th to September 10th

Miles from Port Angeles
Hundred Feet Elevation
Natural Flowing Springs

21

Relaxing recreation for the whole family. Enjoy healthful swimming in the large outdoor pool . . . small, warm pool for children. All cabins are equipped for light housekeeping.

WE FEATURE SEAL OF DARIGOLD GUARANTEED Quality by Angeles

OLYMPIC HOT SPRINGS
PORT ANGELES, WASHINGTON
HARRY SCHOEFFEL, Owner
Telephone: Call Operator

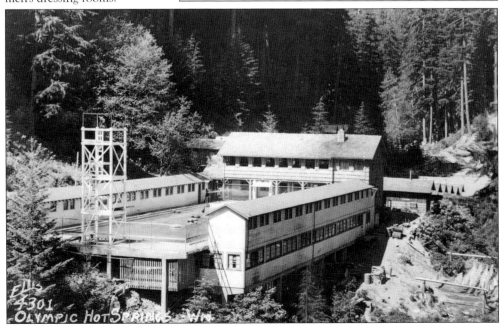

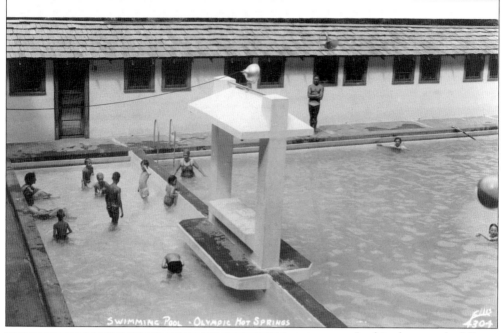

SWIMMING POOL · OLYMPIC HOT SPRINGS

In this photograph, folks are enjoying the pool in the 1940s. Olympic National Park tested the water for levels of required chlorination. The busy owners were new at being a "concessionaire," and the imposition of new regulations from the park service had affected not only Olympic Hot Springs but other resorts that had been annexed by the administration in 1938.

Guests stroll along the boardwalk toward their cabin. The Honeymoon Cabin, located at the north end of the walk, featured a magical view of the resort and Crystal Ridge.

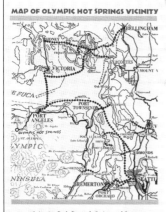

MAP OF OLYMPIC HOT SPRINGS VICINITY

A TREASURE IN HEALTH AWAITS YOU

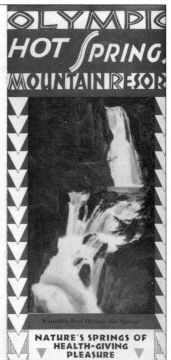

OLYMPIC HOT SPRING MOUNTAIN RESOR

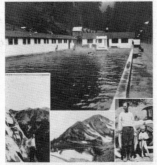

Upper—View from Lodge of the Plunge, Largest, Finest in Northwest; Left—Short Hike from Lodge; Center—Mt. Appleton; Right—Three Beauties from Boulder Lake.

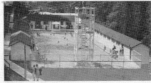

Bird's-eye view of Ultra-Modern Pool

Waterfalls Near Olympic Hot Springs

NATURE'S SPRINGS OF HEALTH-GIVING PLEASURE

Swimming Pools Extremely Sanitary and Sporty

BY a careful system of emptying and refilling, the pools at Olympic are always clean through a constant change of water from Nature's own heating apparatus. The private baths are waited upon by competent attendants. Here special baths may be taken for ailments that the mineral waters will relieve, or for merely a good and refreshing bath after a hard day's tramp over a ranger's trail. Asking to have a bath ready on your return from an outing will mean that everything will be in readiness for you.

Our Fine Lodge and Private Cabins

As the swimming pools and baths are models of sanitation, so is the lodge one of the most typically rustic resorts in the West. There are 800 electric lights for lodge and cabins; long-distance telephone connections; handsome, rustic lodge lobby and hotel service equal to the best. In addition to cold water on tap, hot mineral water is also on tap at various places on the grounds.

At the camp store all sorts of provisions and groceries may be obtained at prevailing market prices. Stock is always kept up so that those who cook their own meals in their cabins may have as large a variety as though they were in their own homes.

There is daily mail service, and regular maintained taxi service from the lodge to Port Angeles over the splendid new highway and through the giant virgin timber of the Olympic forest.

Fall Hunting Trips in the Hills

The coming of the fall season opens a new scope of sport for the out-doors person and the Olympic Hot Springs management has made ample provision for hunting parties as to equipment, pack

DIRECTIONS -- RATES

Take motor bus leaving Seattle daily at 8:00 a.m. or boat leaving at 12:00 midnight for Port Angeles.
Our car leaves Port Angeles during July and August daily at 1:30 from motor bus depot. Other months on Saturdays. Round trip

A fine brochure was sent out to entice guests to come and enjoy the amenities. Among the selling points were these words: "nowhere but in the Olympics can such scenery be found" and "the resort has been made capital of the largest plunge in the Northwest, amidst unsurpassed scenic grandeur, to exercise or loaf to one's content!"

WHERE TWENTY-ONE HEALTHFUL HOT SPRINGS BUBBLE

OLYMPIC HOT SPRINGS, situated in the scenic center of the Olympic Peninsula, presents an opportunity well worth consideration by the vacationist whether he has two days or two months to spend in healthful recreation. Here, at an elevation of 2100 feet in the Olympic Mountains, is fishing supreme, hiking and mountain climbing, bathing and swimming in the health-stimulating waters of 21 hot springs, motoring amidst unsurpassed scenic grandeur—exercise or loafing to one's heart's content.

Olympic Hot Springs is easy to reach. By fast ferry one can go directly from Seattle or Victoria to Port Angeles and then drive over a fine highway for 21 miles to the lodge. By a combination of motoring and ferrying from Seattle to Olympic Hot Springs a most enjoyable trip may be had—ferry from Seattle to Bremerton, drive from Bremerton to Seabeck, ferry from Seabeck to Brinnon, then drive from Brinnon to the lodge by way of Quilcene, Sequim and Port Townsend. Another combination motor and ferry route may be taken by ferrying from Edmonds to Port Ludlow, driving on the Olympic Highway to Port Angeles, then south to the lodge.

Imagine the pep he is starting the day with. Envy him?

Scenic grandeur even the Swiss Alps cannot surpass

SCENERY IS UNSURPASSED

OLYMPIC HOT SPRINGS is on an arm of the Elwha River, with the towering Olympics rising all about. A view in particular that will remain forever in the mind of the motorist approaching the Springs for the first time is that had by stopping at Lookout Point and looking back at the majestic mountain and lake scenery spread out before him. Even Victoria, B. C. can be seen across the straits from this point. The splendor of this sight must be seen to be truly appreciated—nowhere but in the American Alps, the Olympies, can such scenery be found. Guests who enjoy fishing will find encouragement in their luck. Streams are fairly alive with hungry trout whose eagerness to bite is responsible for landing many of them on the dining tables of the lodge. Hiking back into the hills opens a wide panorama of rugged beauty. A good two-hour tramp over the hill from the lodge brings the vacationist to mirror-like Boulder Lake, and snow banks that remain practically all summer. Rugged scenery, rushing waterfalls, huge trees, and bear, elk and deer constantly on the move through the forest give the outdoor man or woman a sense of truly having left civilization behind for a real summer's outing.

ABOUT THE LODGE—Upper, Before the Big Fireplace in the Lodge; Center, A Bear Cub on the Grounds; Left, A Trail to Hiking Thrills; Right, Elk near Olympic Hot Springs Mountain Resort.

FOR A COMPLETE VACATION

OUTSTANDING and most remarkable feature at Olympic Hot Springs is, of course, Nature's twenty-one health-giving hot springs which bubble out of the ground boiling hot, their zestful mineral odor alone testifying to their medicinal value. Because of the valuable qualities of these waters, this feature of the resort has been made capital of, the largest plunge in the entire Northwest being found at Olympic Hot Springs. Here every sort of bathing may be enjoyed and everyone from baby brother to grandmother will have aquatic sport to suit. Adjoining are private baths, mud baths, and baths which may be taken in hewn-out cedar log bathtubs, specialized use of which has proven extremely beneficial in the treatment and cure of rheumatism. The huge cedar logs have been hollowed out and finished to a remarkably hard, smooth surface, making bathing in these cedar logs a delightful experience. There is something about the ideal and happy combination of nature's elements at Olympic that makes for more than a complete rest and vacation. The combination of rugged mountain scenery, clean, pine-scented air; invigorating mineral baths that completely relieve tired muscles after a strenuous day; hiking, fishing and swimming topped off by the best meals you've ever eaten—it's a combination hard to beat.

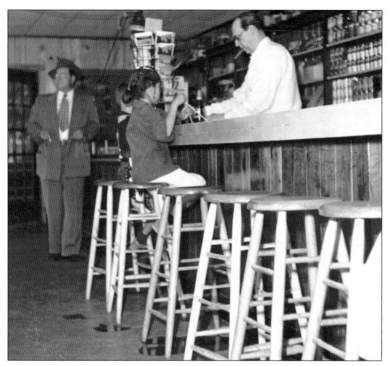

Harry Schoeffel, the resort's proprietor, is at his post behind the counter, tending to his guests. Schoeffel was a natural host, with his ever–present cigar and his gold tooth. He would make a "hissing" laugh that added to his fun-loving personality. A hiker in his youth, Schoeffel loved to fish and play cards while drinking whiskey and puffing on his cigars.

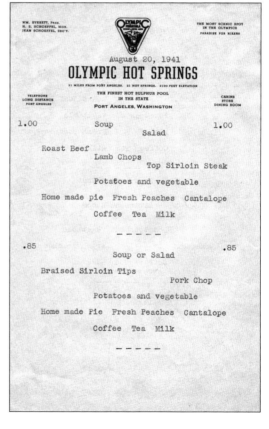

Shown here is a humble menu from the dining room in 1941. Jean Schoeffel worked long hours cooking for the guests and staff. She became much appreciated for her fine cooking and pie-making. Schoeffel gathered mushrooms in the nearby forests and berries that grew on the hillside for her wonderful pies and jams.

Here is Cabin No. 19, a favorite of some due to the way it was perched over Boulder Creek. The cabins along the cliff were set on pilings, which tucked them in to the side of the canyon. The northwest side of the swimming pool was also built on pilings along the ravine.

Early morning mist, smoke from the wood stoves in the cabins, and steam from the hot mineral water create an ethereal scene at the resort. Over 4,000 visitors came through the Elwha entrance to Olympic National Park in 1941. Surely, many, if not all of them, found their way to the springs.

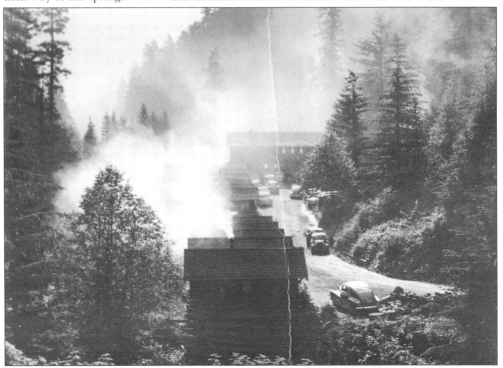

In the left photograph, a pal pretends to throw Bobby Schoeffel over the bridge into Boulder Creek. Schoeffel received his driver's license in 1942, and he is pictured below (right) lounging on top of his car. He was known to hold the record for the fastest drive down Hot Springs Road to Highway 101. Many tried to beat his time, including the resort cook, Vera Feltz, who would fly by the Elwha Ranger Station on her way to work, still carrying a citation from the week before. She cooked for the Schoeffels for six years in the 1950s.

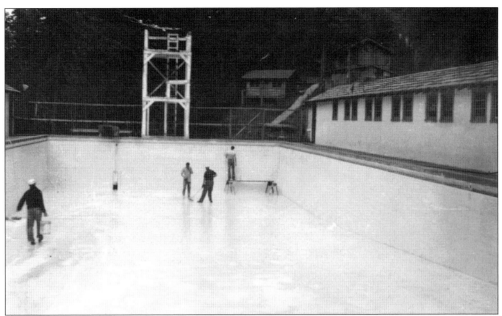

Cleaning and painting
the cement pool was quite
a job. Bobby Schoeffel is
on the far right, standing
on top of the bench.

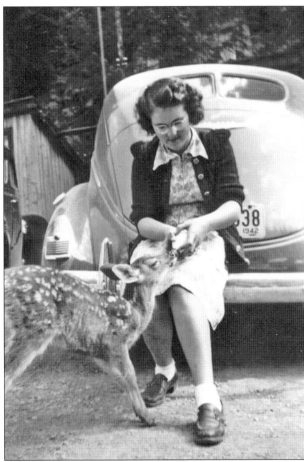

Florence Hassell Pressley, who
worked at the resort for many
years, befriended this fawn.
She had relatives by name
of Ed, Everett, and Harriet
who were also employed.

In the left photograph, Pete Capos, a beloved host and manager of the American Legion Club in Port Angeles, is ready to dive into the pool in 1949. Capos was great at remembering names and was noted for his charm. He was a restaurant manager with Sam Haguewood for many decades. In the below photograph, Capos (right) spends a summer afternoon with Guy Oel (center) and Sheriff Roy Kemp. Capos, with help from the sheriff, is about to toss Oel into the pool. Oel owned the Gateway Tavern in Port Angeles.

Eight

Snow Scenes

At the end of the summer, with the young heading back to school and the hired help laid off for the season, the buzz of the business season would slow down. The winter would bring beautiful quiet time to Harry and Jean Schoeffel at Olympic Hot Springs. The couple would have time to themselves to get caught up on their tasks of closing the resort until the following spring. There were pipes to wrap, employee quarters to clean, and repairs to be made almost everywhere. It would be just the two of them for weeks until someone braved the two to three feet of snow to bring the gift of company and supplies. Harry would catch up on reservations and mail forgotten items back to guests. Jean would restock for next season and keep the two fed. In the heavy winter months, guests were few, except for an occasional visit from ducks that flew in for a swim in the pool or a deer or bear stopping by looking for a handout. This chapter features photographs taken by Jean and Harry Schoeffel during the winter months as they were tucked in their white sanctuary of snow.

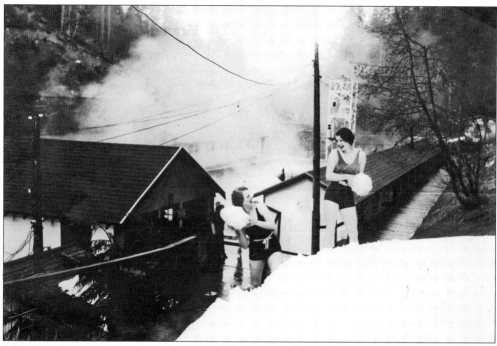

This 1936 photograph may have been staged for a postcard or advertisement. Hopefully, not many retakes were required for these young ladies.

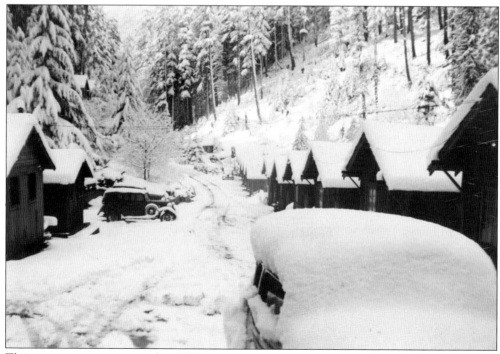

This snow scene was captured in 1938.

Harry Schoeffel enjoys a jaunt on skis.

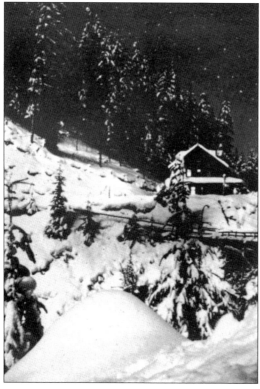

This postcard features the hotel at night before it burned down in January 1940.

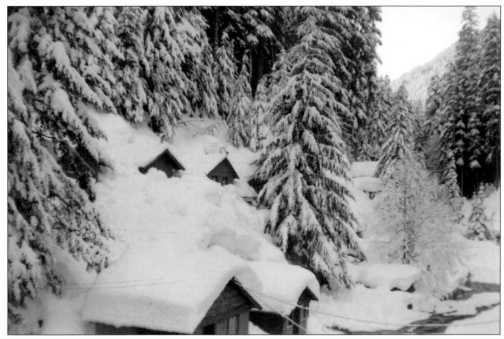

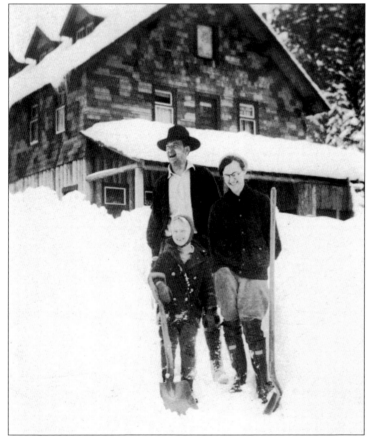

The snow would transform the resort into a wonderland, but it also brought trouble. The Schoeffels often worried about the roofs collapsing under the weight of a fresh snowfall.

Harry and Jean Schoeffel, with their son, Bobby, pause while shoveling snow in front of the hotel during the winter of 1930.

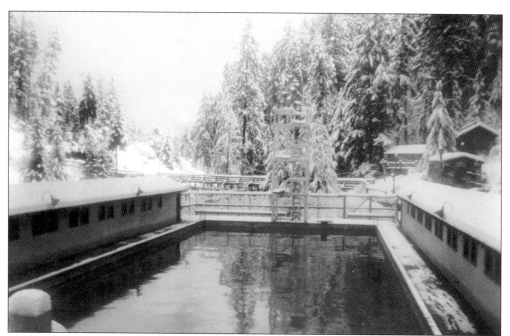

During the winter, the Schoeffels would occasionally take leave to visit family in Pittsburgh or in California, leaving caretakers to watch over the place. In January 1940, they returned to find their lodge burned to the ground, a result of a chimney fire, and some cabins collapsed from the heavy snow.

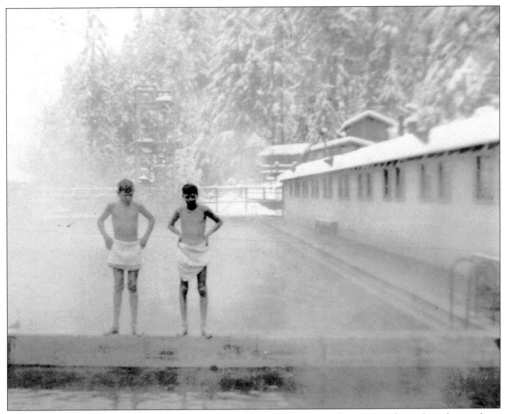

Young Bobby Schoeffel (right) and his friend have gone into the mineral pool without their swimming trunks in 1937.

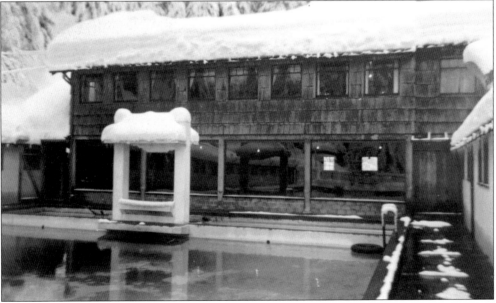

The pool area, frozen and quiet while under the spell of winter, waits for the thaw of spring and the sounds of splashing and laughter.

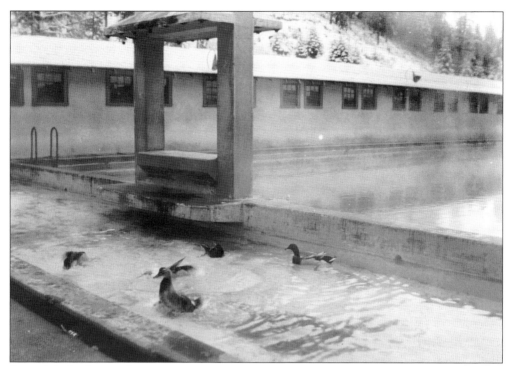

Several ducks drop in for a warm soak in the mineral water pool, probably to warm up their feet while traveling south for the winter.

Harry Schoeffel takes a step outside in 1954 and gazes upon the white wonder of snow. He often spoke of a bear he was forced to shoot when it came into the lodge through the back stairs. The bear was drawn to the smell of Jean's cooking, which was hard to ignore.

This photograph reveals gridlock on the road to Olympic Hot Springs. When the Schoeffels' fleet got stuck in the snow, Harry came to the rescue with a tractor to pull them out.

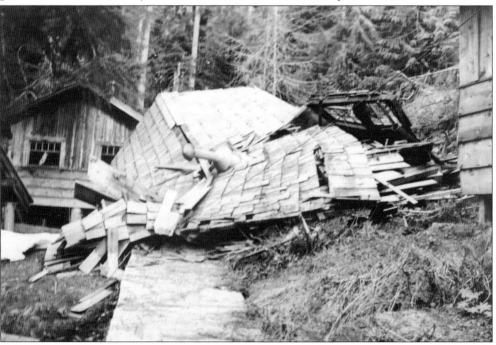

One of the cabins gave out under the strain of heavy snow in 1953. Such events were among the burdens that came with enjoying the white wonder the winter would bring.

Nine

THE FIFTIES AND SIXTIES

When the Olympic Hot Springs entered into the decade of the 1950s, it had been hosting thousands for 43 years. Surviving two fires and the passing of all the original founders, Jean and Harry Schoeffel struggled with the realms of control from the Olympic National Park. The two had wonderful yet wearying years together running the resort. They became grandparents and had many of their grandchildren spending summers with them, finding jobs for them about the place.

Notable names and guests had come and gone, along with the drowning of young Chester Smith in the pool. The music was faster and the swimsuits were scantier. In 1955, the National Park Service would not let them use the mineral water in the pool. This reduced their business drastically, as the mineral water was a main attraction. Some 40 churchgoers came up for a communal baptism in the pool, and the cook for years, Vera Feltz, would outrace the park rangers on the winding road while late for work. Harry had a continual disturbance with a bear and by use of a set of old bedsprings, a ham, and an electrical current, that bear never came back to the resort.

As the 1960s came, bringing Kodak color film and color television, the resort was aging and reluctant to move to the modernization of the era. The British invasion of the music scene and man landing on the moon did not challenge the rustic resort. The waterwheel had long been retired, and a diesel generator replaced it. Jean and Harry Schoeffel, almost 70, were battling with the national park over their leases, and issues between the two continued. The Vietnam War draft took a few of their employees, and a young man was lost over the side of the winding road to the springs while driving his brand new 1963 Corvette. While the Seattle World's Fair brought marvels of new technology in 1962, the guests at the Olympic Hot Springs resort cooked meals in the cabins on wood stoves.

In 1966, with hundreds of scheduled reservations for the season, the national park would not renew the lease for the wavering resort. After a life span of 59 years, this would be the last year the resort would operate. With humiliation and great financial loss, as they could not receive fair market value for their life's work, Jean and Harry Schoeffel lost their six-year legal battle with the US government and were forced to leave their home. The lodge buildings and cabins were destroyed, burned, and bulldozed into the large cement pool and then covered with the same earth that the springs themselves had emerged from. The life of the resort was over, leaving decades of memories behind.

Today, those who hike the Elwha Trail to the mineral pools in their natural state find the muddy ground of the hot springs site reveals chunks of concrete emerging from the earth as if to protest the demise of a legacy and to bring to light that there once was a beloved resort there called the Olympic Hot Springs.

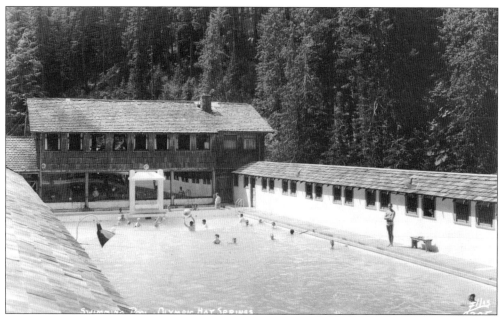

This lodge, built in the spring of 1940, had a lobby with a store, an upstairs dining room, and quarters downstairs with private baths for the help. A huge bust of a stuffed elk hung over the landing on the stairs leading to the second floor. Windows all around the lodge looked out onto the pool. The smell of sulfur from the mineral water would mingle with the delightful odor of Jean's cooking and the habitual smoke from Harry's cigars as he worked behind the counter attending to his guests.

Bob Schoeffel was a regular host during the summers. Bob, a jack of many trades, was his parents' only child and so was a continual presence at the resort. Here, Bob is seen with his cousin Milton Diedrich from California. Diedrich had brought his family up for a vacation in 1950 in one of the "Woodie" wagons pictured here.

116

The well-remembered water fountain (above) offered mineral water to drink. Nearly all who imbibed it would do so while pinching their nose to avoid the smell. In 1910, the City of Port Angeles, wanting a slice of the mineral water pie, approached the US Forest Service with ideas of piping it 21 miles to town. The proposal never materialized. In the right photograph, an unidentified beauty poses on the diving board.

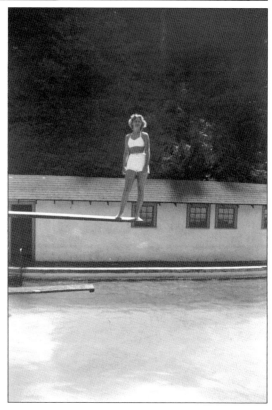

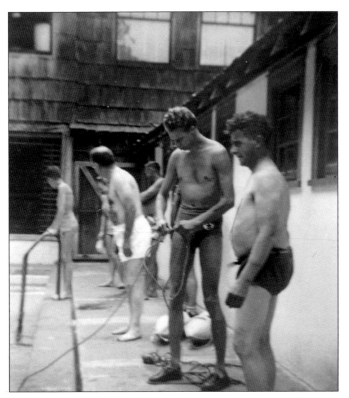

In the left photograph, Bob Schoeffel, holding onto a hose, and others take a first aid/lifesaving course in 1952 after the drowning of Chester Smith in 1951. A local boy, Rich Headrick (below), worked as a lifeguard during the summer of 1954 and later went on to become a judge for the Port Angeles community.

1955
Scholarship
Student

Port Angeles

RICHARD HEADRICK

KIWANIS CLUB
Port Angeles, Washington

On the right, Turton twin Gale and Dale play in a chair inside the lodge lobby with young Lurie Schoeffel, the granddaughter of owners Harry and Jean Schoeffel, in 1953. The Turton twins spent many summers at the resort with their parents, Joe and Evelyn, who would pick up hitchhiking kids in their 1948 Flathead 8 along the winding road to the resort.

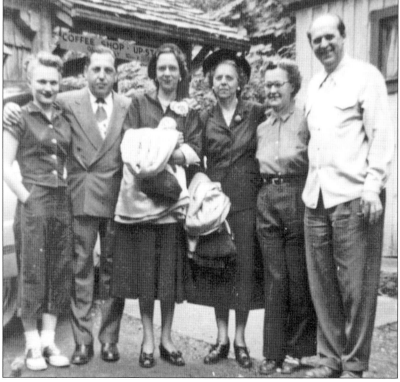

Harry Schoeffel gets a special visit with his sister from Waumpum in 1950s. From left to right are his daughter-in-law Fran Schoeffel, his nephew-in-law Jim Ross, his neice Alberta Ross, his sister Edna Chatham, his wife, Jean Schoeffel, and Harry himself.

Here is the Elwha Store, which operated for 74 years and was the last fueling station on Highway 101 en route to the Olympic Hot Springs. The Schoeffel "Woodie" station wagon is fueling up for a trip to Port Angeles for supplies in 1954.

Three of Harry and Jean Schoeffel's grandchildren are in the small mineral pool in 1957. From left to right are Ron Dearinger, "Tweetie" Schoeffel, and Rick Dearinger with their mother, Dottie Schoeffel, looking through the door.

Fred Schoeffel, who would work summers at the resort and is the oldest grandchild of the owners, poses here with Beth Ann Ross (center) and his young sister "Tweetie" (left) with a catch of fish from Freshwater Bay in 1965.

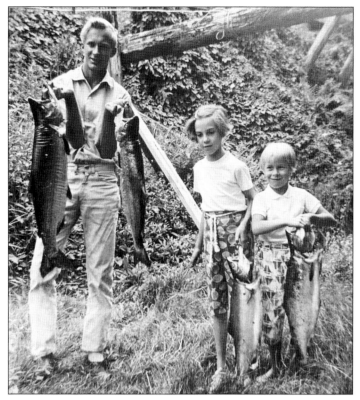

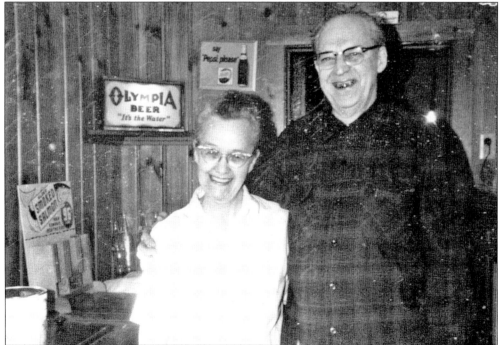

This photograph was taken in 1965, a year before the resort closed. Hosts Harry and Jean pose for the camera.

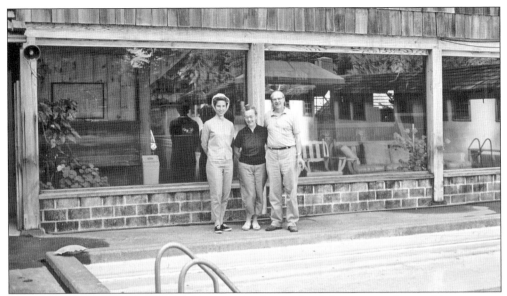

As Kodak brought color to the world in 1960s, the words of the writers who would attempt to describe the beauty of life without color photography did not have to linger as long with the pen. Here is Patsy Diedrich from California (right), a great niece of Harry and Jean, in front of the lodge in 1964.

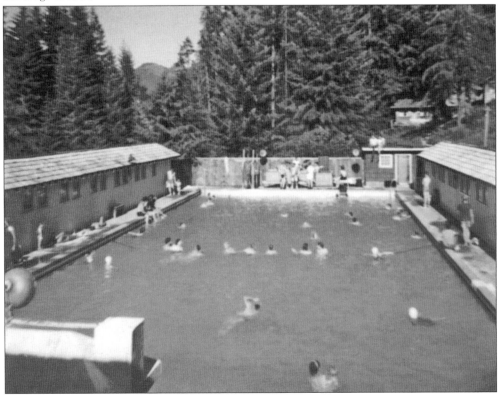

A rock and roll band plays at the far end of the pool as the last season of Olympic Hot Springs resort comes to a close in 1966.

The legal battle begins between Harry and Jean Schoeffel and the US government regarding the closure of the resort. A Port Angeles news article, which is one of many, starts to inform the public of proceedings in 1967.

Testimony ends in Hot Springs dispute

Testimony in the $67,000 Olympic Hot Springs suit against the U.S. government ended Tuesday before Commissioner Marion T. Bennett here to represent the U.S. Court of Claims.

The suit brought by Mr. and Mrs. Harry Schoeffel, former owners of the Hot Springs concession, alleges the government owes them $67,000 based on "fair market value" of the property when their Park Service contract was terminated in 1966.

Additionally, the Schoeffels are seeking $200,000 for water rights and $500,000 for perfected mining claim rights in related suits against the government.

According to William J. Conniff, attorney for the Schoeffels, the government is only willing to pay "book value" of $10,200 for the property.

At issue is whether a clause inserted in the Schoeffel's contract with the Park Service in 1965 is valid. The clause, not in any previous contracts signed by the plaintiff, stipulated the Hot Springs could be bought at "book value" Conniff said.

Prior to that, all contracts the Schoeffel's signed provided for "fair market value." Conniff added.

It is the contention of the Schoeffels that the clause was inserted into the contract they signed in 1965 without their

knowledge, Conniff said.

Furthermore, a contract signed by the Schoeffels in 1958 indicated they would receive fair market value for the property for which they made $30,000 in

improvements, he pointed out.

Conniff said evidence presented here will be argued before the 9-man U.S. Court of Claims in Washington, D.C., for a final judgement.

Last trip not least for glacier plane

The last trip of the season to Blue Glacier is turning out to be something more than the least for Puget Sound Airlines.

Tuesday, while flying the sole remaining glacier run to retrieve University of Washington scientist Sam Colbeck, the plane's nose became stuck in a crevasse just before takeoff about 3:30 p.m.

The Coast Guard sent a helicopter flown by Lt. Cmdr. Gerald W. Barney to bring out the PSA pilot, Dick Ferrell, and Colbeck who had reportedly returned to his summer home for a final inspection.

Today, the airlines reports high winds and lack of a suitable glacier landing aircraft are preventing the repair and return of Ferrell's plane.

According to Mrs. Mary Fairchild, airport supervisor,

PSA is additionally, facing the problems of getting the plane out of the crevasse and doing it before a long siege of bad weather sets in.

The plane reportedly suffered a damaged landing strut and propeller while taxiing to the high end of the glacier for takeoff. No injuries were reported in the incident.

Somali head is killed

NAIROBI, Kenya (AP) — Dr. Abdirashid Ali Shermarke, president of the Somali republic was shot dead this afternoon by a man said to be wearing a police uniform.

Radio Mogadishu interrupted its programs to broadcast the news.

Tweetie Schoeffel (Teresa Lingvall and author of this book) is in the pool in 1962.

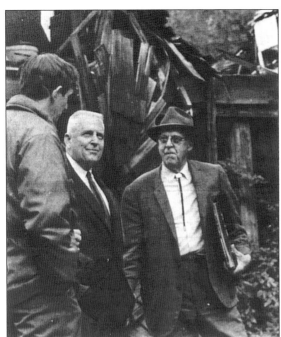

Harry Schoeffel (right) stands determined while facing the camera of a Port Angeles newspaper reporter as buildings have begun to collapse after the closure of his resort. He is here with Benett Gale, Olympic National Park superintendent (center), and park ranger Jack Hughes (left) in 1969 to assess what should be considered "fair market value" for the park's reclamation of his life's work. (Courtesy of *Port Angeles Evening News*, photograph by Flynn J. Ell.)

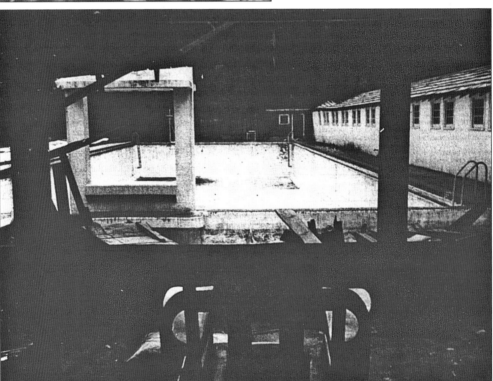

Journalist Flynn J. Ell did a story in the *Port Angeles Evening News* about the closure of the resort and how it effected him. He states in his story, "viewing this scene, it is the first time this writer has ever questioned the idea of conservation or maintaining the natural environment." Here he took another photograph of the pool from the vacant lobby of the lodge in 1971.

A sad fate befell the resort piano, which was in the lobby of the lodge. Here it is left behind as the resort falls down around it. Many fingers touched its keys as it rang tunes during its reign on the cement floor. Children would find coins under it that had fallen from guests' pockets and would go to the counter to buy a candy bar or ice cream. (Courtesy of *Port Angeles Evening News*, photograph by Flynn J. Ell.)

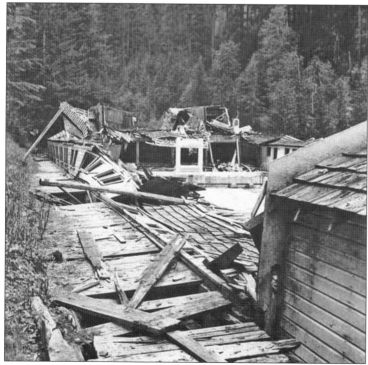

This photograph is difficult to appreciate and it hurts anyone to view the apparent suffering of the dilapidated remains of the Olympic Hot Springs resort. The resort seems to ask for relief from its loss of dignity and waits for final demolition to be put out of its misery. The beloved resort, though sorrowful in this photograph, generously gave many good memories, along with sounds of laughter and good times spent. (Courtesy of Olympic National Park Archives.)

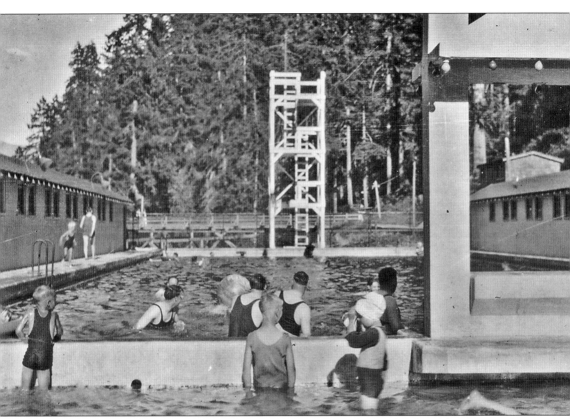

Looking away from the previous photograph, it is easy to imagine the days Olympic Hot Springs was alive and a destination resort that once stood upright and proud as a host to thousands. The history and love for it will be here in this book for all to share and remember. (Courtesy of Marie Cauvel.)

The End

DISCOVER THOUSANDS OF LOCAL HISTORY BOOKS FEATURING MILLIONS OF VINTAGE IMAGES

Arcadia Publishing, the leading local history publisher in the United States, is committed to making history accessible and meaningful through publishing books that celebrate and preserve the heritage of America's people and places.

Find more books like this at
www.arcadiapublishing.com

Search for your hometown history, your old stomping grounds, and even your favorite sports team.